Acrylic
Workbook

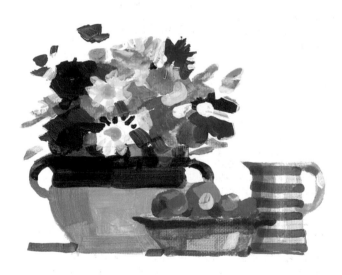

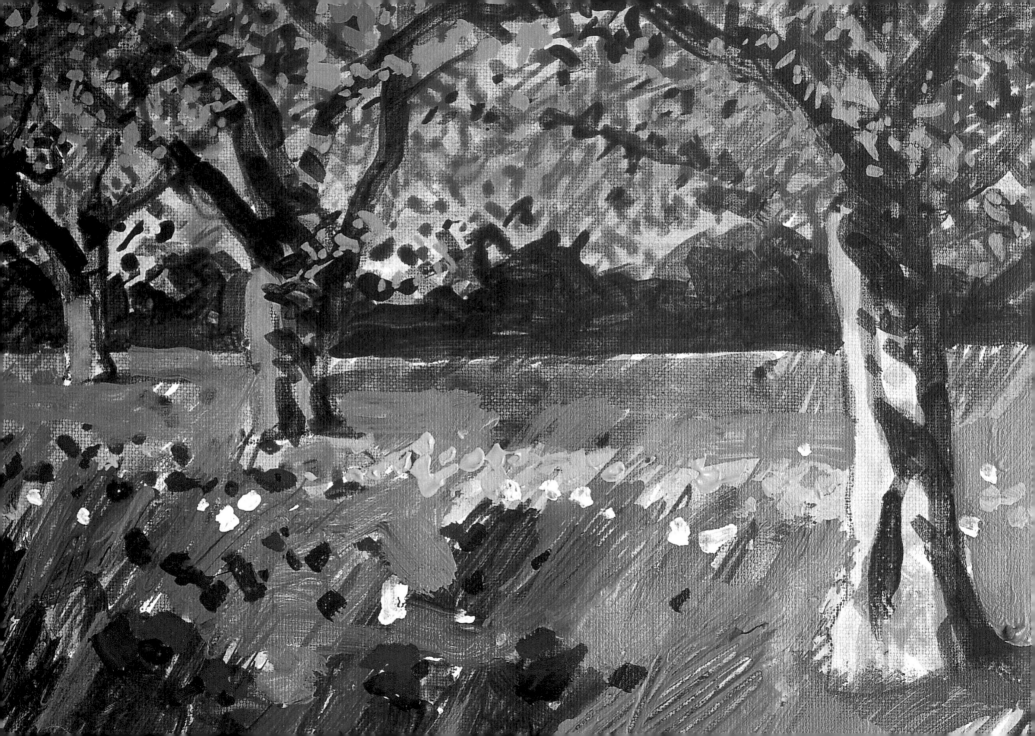

Jenny Rodwell

Acrylic Workbook

A COMPLETE COURSE IN TEN LESSONS

David & Charles

ACKNOWLEDGEMENTS

The author would like to thank Ian Sidaway for the artwork and painting demonstrations; Ian Howes for the photography; Adrian Smith for the sketchbooks on pages 18-19; and Winsor & Newton for their generous help with materials.

Page 2 The Olive Grove

A DAVID & CHARLES BOOK

First published in the UK in 1998

Copyright © Jenny Rodwell 1998

Jenny Rodwell has asserted her right to be identified as author of this work in accordance with the Copyright, Designs and Patents Act, 1988.

A catalogue record for this book is available from the British Library.

ISBN 0 7153 0720 7

Book design by Les Dominey Design Company, Exeter and printed in Italy
by New Interlitho SpA

for David & Charles
Brunel House Newton Abbot Devon

Contents

Introduction

Acrylics are the most versatile of all paints. They can be used instead of watercolour, oil or gouache, having many of the advantages, yet very few of the drawbacks, of these traditional colours. More important, acrylic is an exciting medium in its own right, with qualities and advantages which are unique.

TRANSPARENT OR OPAQUE
Used straight from the tube, acrylics are opaque. This makes it easy to paint one colour over another – a boon when it comes to correcting mistakes. Even when painting a light colour over a darker one, one coat is usually enough to completely cover the colour underneath.

By diluting acrylic colours with a lot of water, you can achieve an effect which is identical to that of a watercolour painting. Using this technique it is easy to create bold or subtle translucent washes, create splashy, random textures, or work in a precise, controlled manner – all in a way which makes the results indistinguishable from watercolour.

However, acrylic is no mere substitute for other types of paint. Although it can be made to look like watercolour, acrylic does not feel or behave like watercolour when you are using it. Unlike watercolour, acrylic washes are insoluble when dry, so once the colours have dried they cannot be removed. This allows you to lay one transparent colour over another, to create glowing colour mixtures without disturbing or dissolving the colours underneath.

THE QUICK-DRYING FACTOR
The most striking thing about acrylics is their quick-drying quality. This means colours can be applied thickly to create a whole range of patterns and thick textural effects which go far beyond the capabilities of traditional oil paint.

It also allows you to paint one colour over another almost immediately, whereas an oil painting might have to be put aside for days before work can be resumed. When working with acrylics the most effective approach is to adjust the colours, tones and composition of your painting by overlaying the paint rather than manipulating wet paint on the canvas as with oils. For those who have become used to oil paints, this will take a little getting used to.

In addition, acrylics are adhesive. The paints and the mediums which are mixed with them have properties similar to woodwork glue, making them ideal for collage and other mixed media work.

USING THIS WORKBOOK

This book assumes no knowledge of acrylics. It starts at the very beginning by explaining how to arrange and mix the paint on the palette – an important skill, but one which is often overlooked. This will enable you to organise and control the acrylic colours as you work through subsequent exercises and lessons.

It is important to follow and complete all of the lessons in chronological order. Each lesson introduces new information and techniques which are then included in subsequent lessons.

PERSONAL DEVELOPMENT
Learning to paint is essentially a 'hands on' process. Apart from following the main project paintings in each lesson, it is a good idea to practise some of the theories and ideas which are discussed and illustrated, but which are not part of the step-by-step project paintings.

For example, colour mixing is central to

painting. The colour mixture charts in Lesson One are intended as a helpful guide, but you will learn more by mixing the colours yourself and by making your own set of charts than by simply using the examples in this book as a reference.

Similarly, texture is synonymous with acrylic paint. A selection of textures is illustrated in Lesson Three and some of these are introduced in the project paintings on pages 48 and 54. By trying out the suggested textures before embarking on the lesson, as well as developing a few of your own, you will gain useful practical experience and as a result, you will be better equipped to complete the project painting.

More important, you will develop confidence and a personal repertoire of marks and textures which will stand you in good stead in future painting.

DRAWING SKILLS

Although drawing is an important first stage of most paintings, very few of us draw as well as perhaps we would wish. Drawing does improve with practice, however, and a temporary lack of skill – or an imagined lack of skill – should not hinder the pleasure of enjoying learning to paint.

For those who feel they cannot draw,

each painting project in the book starts with an outline drawing of the subject. Use this outline as a guide to get started. Do not worry if your initial drawing looks less than professional, or is not exactly the same as the drawing in the book.

No two artists work in the same way, and you should not expect to reproduce carbon copies of the projects in this book.

Rapid colour sketches – see Lesson Nine (pages 108-109).

Materials and Equipment

Fifty years ago most artists painted with either oils or watercolour. As acrylics became more widely available, many painters changed to the new medium, while others carried on using the materials they had become used to.

It is only in comparatively recent years that we find artists who actually learned to paint using acrylics. Some of these painters have never worked in any other medium.

With this generation, acrylic paints have come into their own. The medium is popular for its creative potential and extreme versatility. No longer are acrylics compared with other types of paint, nor are they used mainly to imitate the effects of watercolour or oils.

WHAT ARE ACRYLICS?

All paints are made from coloured pigments mixed with some sort of adhesive which holds the pigment particles together. Although the pigments used in acrylics are exactly the same as those used in watercolours, oils and other types of paint, acrylics have a unique ingredient: the synthetic resin which binds the pigments together. It is the nature of this binder which makes acrylics the most durable and hardwearing of all artists' paints. Once dry, acrylic colours form a tough plastic coating which is almost indestructible.

ACCESSORIES AND ADDITIVES

All you really need for painting are a few tubes of paint, a brush and a surface to paint on. However, a vast array of mediums is available for use with acrylic paints, each of which modifies or enhances the paint in a particular way.

These additions include gels for creating textures, paste for building up the paint surface, mediums to create matt and gloss finishes, retarder to slow down the drying time of the paint, also flow improver and glazing medium, as well as a wide choice of varnishes.

In addition to these, there are now a number of new products which can be mixed with the paint to create specific effects. These include pumice, brick and other textured mediums.

WHAT YOU WILL NEED

From this bewildering array of materials, which ones are actually essential? Happily for the artist, by no means all of them.

Choice of colours is basically a personal one. However, it is advisable to start with a limited palette and to become thoroughly aquainted with the mixing potential of these few basic colours before moving on to experiment and discover new favourites.

Similarly, it is unwise and unnecessary to rush out and buy a random and expensive selection of mediums. While some of these undoubtedly produce dramatic and exciting results, too many special effects can be distracting.

For this workbook you will need only a limited amount of materials. The basic palette of 13 colours is illustrated on pages 20-21, and no project involves more than three brushes.

A vast array of acrylic materials is available to the modern artist. These include colours, which come in tubes, jars or bottles; and a range of mediums which affect the appearance and performance of the acrylic colours. However, to start with all you need are a few colours, a brush or two, and something to paint on.

Tip

It is a good idea to stick to the same brand such as Winsor & Newton or Daler Rowney, when buying acrylic products. Manufacturers guarantee compatibility within their own acrylic range, but stress that materials are not necessarily compatible with other makes.

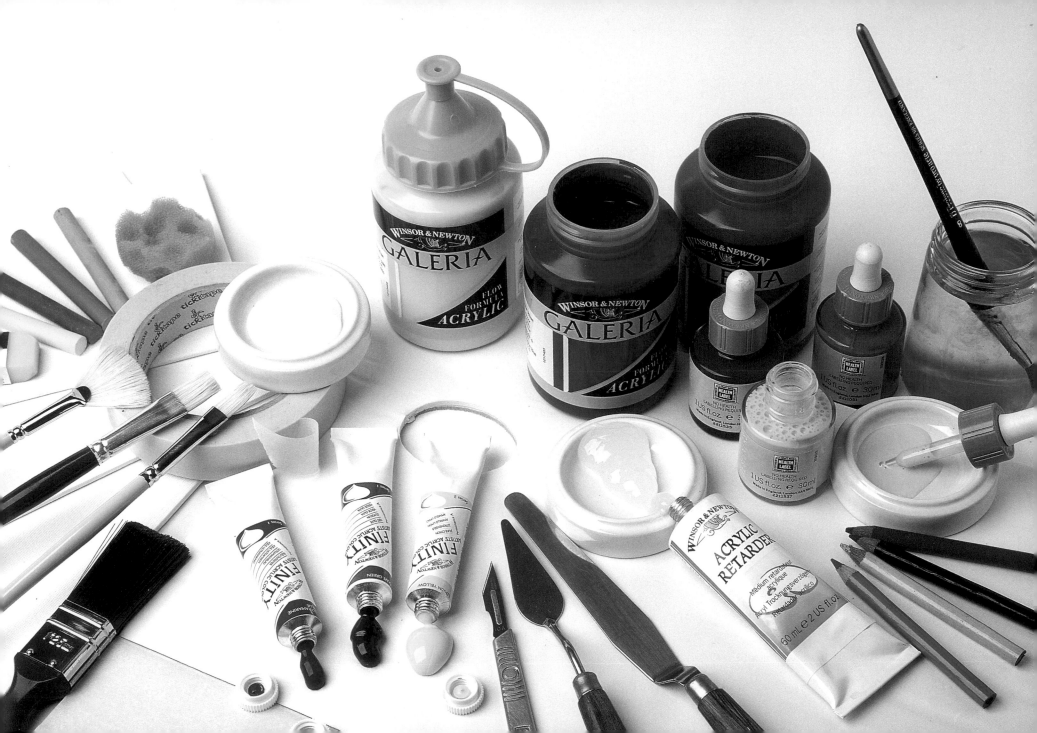

PALETTES

Acrylic palettes are generally made of white plastic and come in a range of shapes and sizes. These are light and portable, and many have a traditional thumb hole so you can hold the palette in one hand and paint with the other.

Traditional wooden palettes are not a good idea because the acrylic paint gets into the grain of the wood and can be difficult to remove.

However, a bought palette is by no means essential. A sheet of plastic, glass or laminated board is just as good, and there is no restriction on size. Many artists choose glass or transparent plastic because this can be placed on a sheet of grey or neutral colour paper making it easier to see how the mixed colours relate to each other. Glass can be made safer by binding the sharp edges with strong tape.

MOIST PALETTES

Acrylics dry quickly and specially made palettes are available which keep the colours moist as you work. These are basically plastic trays lined with a blotting paper covered with a special membrane. Colours are squeezed onto the membrane which absorbs moisture from the blotting paper and keeps the paints moist and workable.

If you are using an ordinary palette, keep the colours moist with an occasional spray of water. Covering the paints with cling film will help prevent the paint from drying out over short periods.

Acrylic palettes are usually made from white plastic or melamine. Alternatively, disposable paper palettes come in a choice of sizes. For small quantities of colour, use watercolour palettes or small mixing dishes.

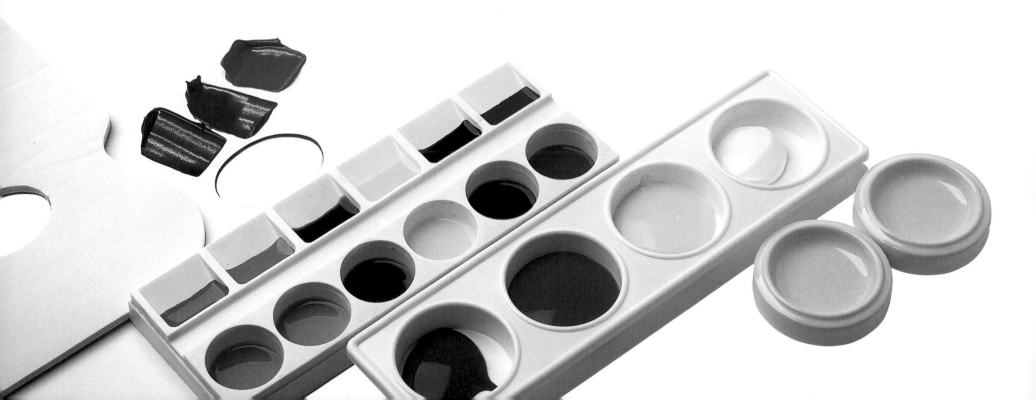

The thickness of acrylic paint varies from brand to brand, but is generally similar to that of oil or gouache. Some manufacturers produce two types of acrylic paint – a standard colour and a more fluid paint which is easier to spread over large areas. Winsor & Newton's Finity paints are slightly less matt than most acrylic colours and dry with a bright, slightly glossy finish.

PAINTS

Most acrylic paints are thick and creamy. They are thinned simply by adding water to the paint on the palette. Very diluted paints will produce transparent colour similar to that of watercolour. Alternatively, they can be used without diluting at all, to give the exciting textures which have become synonymous with acrylic paints.

Paints come in tubes or plastic jars. Standard tube colours have a similar consistency to oils or gouache. The undiluted paint retains knife and brush-marks and is ideal for thick, textural effects.

Acrylic paint bought in jars is likely to be more fluid, good for painting flat, even areas of colour, but less effective for making textures. However, some manufacturers also produce a fluid, free-flowing paint which comes in tubes.

In addition, liquid acrylics are available in bottles with dropper caps. These are similar to concentrated inks – very bright and especially good for watercolour effects and washes.

With such a variety it can be difficult to know where to begin. However, to start with, stick to standard tube colours. These are general purpose, good for all techniques, and are used for the projects and demonstrations throughout this book.

Acrylics come in broadly the same range of colours as oils or watercolours with a few exceptions. Some popular colours, such as viridian and alizarin crimson, do not mix well with the acrylic resin, and alternative pigments have been produced specially for use with acrylic paints.

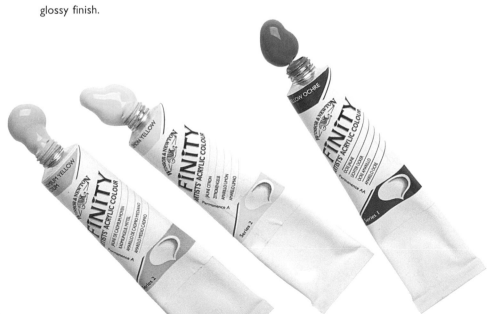

MEDIUMS

Acrylics come with a whole range of mediums and substances which can be mixed with the colours to alter the appearance of the painted surface. They can be squeezed onto the palette and mixed with colour as and when desired.

You can have great fun with these, and can greatly enhance the painting, but none of the additives or mediums are actually essential. They are a means to an end, and should be added to achieve specific effects, not as an end in themselves.

By all means experiment, and decide which mediums are helpful and which a distraction. The only medium used by many acrylic artists is water! Initially, concentrate on using the paint alone. You will get the chance to try texture paste and gloss and matt mediums later in the book.

GLOSS AND MATT MEDIUMS

Used alone, acrylic paints are opaque, and dry to a rather flat finish. A shinier result can be obtained by mixing a little gloss medium with the paint. The more water you use, the less glossy the finish will be. The mixing is usually done on the palette.

Gloss medium makes the colours transparent and is often used when one colour needs to be seen underneath another. It is adhesive and is often used in collage, either as a glue or to increase the adhesive properties of the paints.

Matt medium is used in exactly the same way as gloss medium, but the resulting surface is matt and non-reflective.

GEL MEDIUM AND TEXTURE PASTE

To make the paint thicker, mix the colours with gel medium or texture paste. The gel is similar to gloss medium but thicker. It can be used for building up areas of chunky colour and for creating prominent brush and knife marks.

Texture paste, sometimes called modelling medium, has an added filler and can be used to build up the paint to form a relief surface. Mix the paste with the paint and apply the colour in layers, allowing each layer to dry before applying the next. Too thick an application can crack once it has dried.

There are also a number of specialist texture pastes on the market now, including ones which create the textures of sand, pumice, and other natural surfaces. Do not be intimidated. These are not essentials! You can make your own textures by mixing sawdust, sand, and other substances with the basic paste.

FLOW IMPROVER

Sometimes called tension-breaker, flow improver dilutes the paint without weakening the colour. It is used when a large area of uniform surface colour is needed, but many artists feel it makes very little difference.

RETARDER

This is a transparent medium that slows down the drying time of acrylic paint for several hours. Water reduces its effectiveness, so a retarder is only worthwhile if you want to use paint thickly.

A range of additives and mediums are available for use with acrylic paint. *Left to right from the top:* fluid gloss medium, retarder, fluid matt medium, gloss gel medium, acrylic gesso, texture paste.

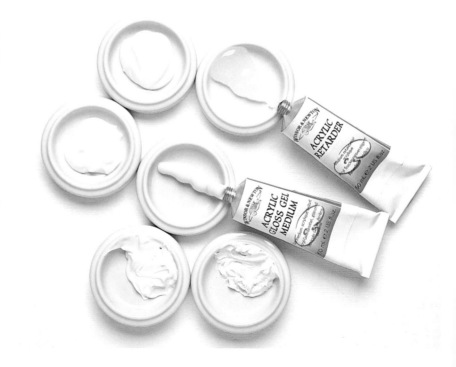

Acrylic mediums are used to alter or enhance acrylic paints. Mediums, which come in tubes or jars, are thickish white substances which may be opaque or semi-opaque. When they are dry, most mediums become completely transparent.

The thickest medium is texture or modelling paste. This can be mixed with the paint to produce thicker colour, or used on its own to create a rugged, textural surface for painting on.

Acrylic gesso is a dense white base used for priming canvas and board prior to painting (see page 17). Clear gesso can be mixed with colour to produce a coloured or tinted painting surface.

Modelling paste, overpainted.

Gloss gel medium mixed with paint.

Clear gesso mixed with paint.

Modelling paste mixed with paint.

Fluid matt medium mixed with paint.

Fluid gloss medium mixed with paint.

BRUSHES

All brushes suitable for oil or watercolour can also be used for acrylic paint. If you already have some of these brushes it should not be necessary to buy new ones. However, if your brushes were last used with oil paint, they must be carefully cleaned to remove all traces of oil and turpentine from the bristles before using them for acrylic.

Brushes for the projects are kept to a minimum – you will never need more than three brushes for any project. Because brush sizes vary depending on the manufacturer, measurements, rather than sizes, are given for the flat brushes. However, do not worry too much about exact sizes – an approximate brush will do.

Watercolour brushes are soft and ideal for applying acrylic colour thinly. Large brushes are best for laying washes and large areas, smaller brushes are useful for painting detail.

Oil painting brushes are stiff, allowing thickly applied paint to retain the texture of the brushmarks. All oil painting brushes come with long handles so that you can stand back from the easel and keep an overall view of your painting as you work.

Decorating brushes, available in hardware stores, are ideal for painting expanses of flat colour or for large-scale works. They come in all sizes with bristle widths from 12mm to 15cm (½in to 6in).

NATURAL BRISTLES

Traditional brushes are made of natural hair or bristle. Soft sable-hair brushes are strong and flexible and the bristles will keep their shape for years if properly cared for.

Stiff brushes are traditionally made of hogs' bristles which are both strong and flexible. Although brushes do eventually wear out, a good hogshair brush will last for a long time. Many artists actually prefer old brushes which have become flexible and worn into particular favourite shapes.

SYNTHETIC ALTERNATIVES

If you intend to invest in new brushes, it is worth considering buying synthetic brushes rather than natural bristle or hair. They are considered particularly appropriate for synthetically based acrylic paints and are well able to withstand the tough handling and cleaning required for acrylics.

Materials used in the manufacture of synthetic brushes have been improved enormously during more recent years. As a general rule, synthetic brushes are less expensive than those with natural bristles. However, as with all artists' brushes, quality products are more expensive.

Whether you choose natural bristle or synthetic fibres, good brushes are well

Brushes suitable for oils and watercolour can also be used with acrylic paints. Shown here from left to right are: synthetic flat, synthetic bright, small synthetic bright, synthetic round, synthetic filbert, soft watercolour brush, decorator's brush, bristle fan, bristle bright, bristle flat, bristle filbert, bristle round.

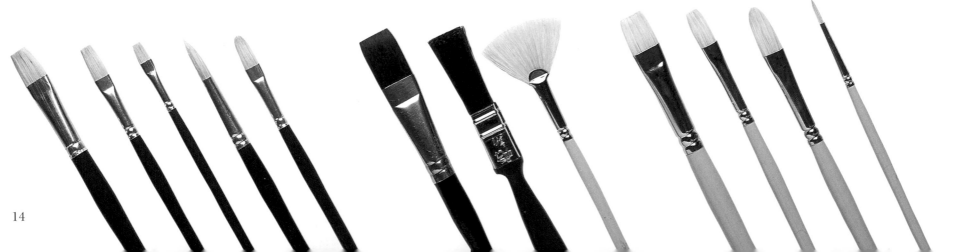

Painting knives come in a variety of shapes and sizes. The four knives on the left are painting knives. These have bent, or cranked, handles which enable you to hold the knife parallel to the painting to apply areas of flat colour. The palette knife, on the right, has a straight flexible blade and is used mainly for mixing and removing colour from the palette.

worth the extra investment, and will last a long time if cleaned and cared for properly.

SHAPES AND SIZES

Brushes come in four main shapes – flats, brights, filberts and rounds. The shape of the bristle head is determined by the length and cut of the bristles and the shape of the ferrule (the metal piece which holds the bristles). Different brushes are used to achieve particular marks and effects. There is more about brushes and the marks they make on pages 46-47.

The bristles of both bright and flat brushes are cut into a square shape. Bristles of a flat brush are longer and flexible, while a bright has a shorter, stubbier bristle head. Round brushes are like water-colour brushes but, being made of bristle, are much stiffer. A filbert brush is a combination of a round and a flat, with long flexible bristles tapering off to a point.

Artists' brushes are available in a wide range of sizes although the size numbers vary from one manufacturer to another.

CARE OF BRUSHES

Wash brushes in water immediately after use. When using a number of brushes for the same painting, lay brushes which are not in use in a shallow tray of water with the handles resting on the edge of the tray. This prevents the paint from drying out and ruining the bristles. Do not stand brushes upright in a jar of water because this causes the bristles to bend.

If paint is accidentally allowed to dry on a brush, soak it in methylated spirit overnight then wash in soap and water.

KNIVES

Use a painting knife to apply solid areas of colour or thick, buttery wedges. These knives come with variously shaped flexible blades and in a range of sizes. Each painting knife has a specially bent handle which makes it easy to control and move the colour around the picture without damaging the canvas or smudging the paint.

Palette knives have straight, flexible blades and are essentially used for mixing and moving paint around the palette.

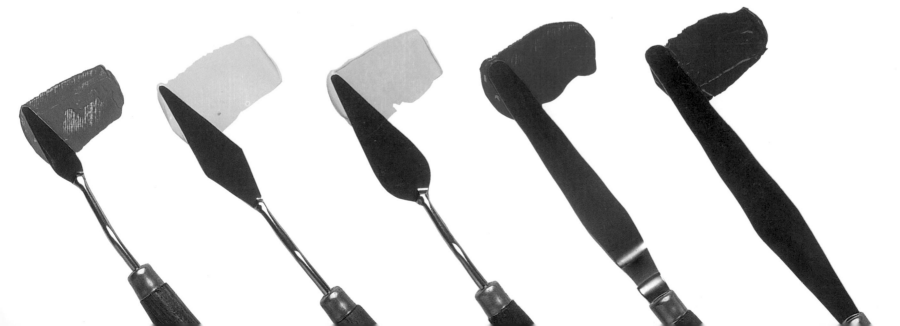

PAINTING SURFACES

Finding something to paint on poses no problem because acrylics can be used on a wide range of surfaces. Conventional surfaces include canvas, board, cardboard and paper, but more unusual surfaces such as plastic, metal and even formica have been used successfully by many artists. All the paintings in this book are done on Cryla paper – a textured, primed paper made specially for use with acrylics. However, any of the surfaces discussed here may be used instead.

All surfaces should be primed to seal the surface and provide a key for the paint to adhere to. Acrylics will not adhere to surfaces which are oily or waxy, which rules out any surface which has been prepared for oil paints only. A surface primed for oils may seem fine at the time you are working on it, but eventually the acrylic paint is likely to come off the oiled surface.

Acrylic gesso or acrylic primer provide a bright white painting surface. To retain the colour of the canvas, board, card or paper, seal the surface with acrylic gloss or matt medium, both of which dry to a transparent finish.

BOUGHT SURFACES
By far the most convenient surfaces are those bought ready-primed for use with acrylic paints. These include stretched canvases, boards and canvas-covered boards as well as specially prepared papers which have a texture similar to canvas.

The drawback of bought surfaces is that they come in a limited range of shapes and sizes, and you are also restricted to the proportions chosen by the manufacturer. For the prolific painter, bought surfaces – especially stretched canvases in larger sizes – can prove expensive.

INEXPENSIVE ALTERNATIVES
A number of perfectly good surfaces are easy to make and relatively inexpensive. For the newcomer to acrylics these are particularly useful because it can be intimidating and costly to start each new painting on a pristine canvas bought specially for the purpose.

The perfect surface for acrylic painting is slightly porous – absorbent enough to take the paint, yet not so porous that the colour sinks in.

Among the most popular inexpensive supports are hardboard and Masonite. Generally, the smooth side of the board is best for painting, but it is perfectly possible to use the rough side if you want a coarse or textured finish. Whichever side you choose, it will need sealing. This can be done either by priming with two coats of acrylic gesso to get a white painting sur-face, or sealing with acrylic gloss or matt

Acrylic paints can be used on a variety of surfaces including canvas, wood, card and paper. Surfaces for painting should be sealed with two coats of acrylic gesso or medium. Surfaces before priming from left to right are: hardboard, cardboard, fine linen, coarse linen, cotton duck, primed canvas, Cryla paper, tinted paper, cartridge paper.

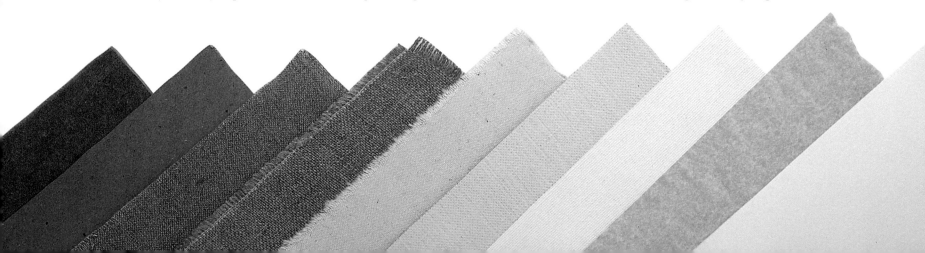

medium to preserve the natural colour of the board. Large boards should be battened from behind to keep the board rigid.

Acrylic medium can also be used to stick canvas, muslin or other fabric to hardboard or Masonite. This creates a rigid support, but with a texture similar to stretched canvas. The fabric should be treated with acrylic gesso or medium.

PAPERS AND CARDS

Cardboard and sturdy paper are fine for use with acrylics, especially for small paintings. Again, the surfaces must be sealed with gesso or medium so the surface is not too porous to receive the paint. If the paper is too thin it will wrinkle, and it should be stretched before applying gesso or medium.

Many artists like to paint on a coloured or toned surface and choose tinted papers or cardboard for this reason. In this case, the surface should be sealed with matt or gloss medium, both of which dry to a transparent finish, so preserving the natural colour of the card or paper.

STRETCHING YOUR OWN CANVAS

It is simple and satisfying to stretch and prime your own canvas, and this way you can also be sure of getting a painting surface which you know will fit your personal requirements.

You will need a wooden stretcher and a length of fabric slightly larger than the frame. Wooden stretcher pieces can be bought in art stores and come in different lengths so you can make your stretched canvas to a chosen proportion and size. The four pieces of the frame slot together and two small wooden wedges at each corner keep the canvas taut.

The most popular canvas fabrics are linen and cotton, both of which come in a variety of weights and thicknesses. Linen is often hand-woven and has a slightly irregular weave. It provides a fine, firm painting surface when stretched and primed and is more expensive than cotton. Cotton is bulkier and softer and is less taut when stretched. Both linen and cotton should be treated with acrylic medium or gesso before use.

It is also possible to buy ready-primed canvas by the metre. This can either be fixed to a stretcher in the same way as unprimed canvas, or it can simply be pinned to a board and used in the same way as card or paper.

Canvas can be fixed to the stretcher with either staples or tacks. It is important not to stretch the canvas too much at this stage because the gesso or acrylic medium themselves have a tautening effect as they dry. Too much tension at the stapling or tacking stage can cause the wooden stretcher to warp.

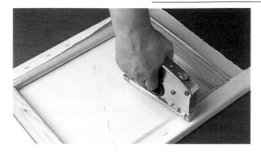

1 Assemble the stretcher and cut the fabric allowing 5cm (2in) extra all round. Staple the fabric to the reverse of the stretcher, starting at the middle of the longest side.

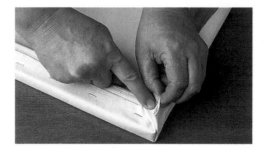

2 Make the corner by folding one edge over the other and stapling diagonally.

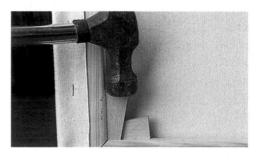

3 Tap the wooden corner pieces into the slots provided until the fabric is uniformly taut but not stretched.

4 Finally, prime the canvas with two coats of acrylic primer or gesso for a white painting surface, or acrylic matt medium if you prefer to retain the colour of the canvas.

WORKING OUTDOORS

For the artist who prefers painting out of doors, acrylics offer a prime advantage. Because they dry so quickly they allow for on-the-spot painting to a far greater degree than traditional oil paints. At the end of the day, the rapidly dried acrylic painting can be packed up quickly and carried home without fear of mess or smudged colours.

THE ALL-WEATHER PAINT

To some extent, climate and weather affect the drying time of acrylic paint. In damp and humid weather, the colour takes rather longer to dry. On a very hot day, colours dry quickly. This can be a nuisance, because the paint on the palette also dries quickly, sometimes before the artist has a chance to get the colour onto the canvas. The solution is to use one of the specially developed membrane palettes which keep the colours moist, or to give the palette colours an occasional spray of water.

CLOTHING AND EQUIPMENT

Portable painting kits, available in art shops, are compact and useful and contain paints, brushes and a palette which fit into a tailor-made box.

Otherwise, pack your materials in a bag which is comfortable to carry, preferably one which can be carried on the back or shoulder, so leaving your hands free. Brushes can be protected by carrying them bristle end up in a cardboard tube or lightweight plastic container available from art shops.

Canvases and boards are generally easier to manage if they are strapped with a handle for carrying. Otherwise, pads of acrylic paper come with a rigid cardboard backing and are ideal for working out of doors.

A folding sketching easel is quite adequate for small and medium-sized paintings, and a folding stool will ensure comfort for the artist who prefers to work sitting down.

Finally, take a jar or mug for painting water, and plenty of rags or kitchen roll for mopping up and cleaning palette and brushes. If you are not sure of being near a source of water, you should take your own in lightweight, unbreakable containers.

PREPARE FOR ALL WEATHERS

Weather and light are constantly changing, so take nothing for granted and be sure to go prepared.

The experienced artist knows that one of the most important items to be packed for an outdoor painting trip is an all-purpose, comfortable hat.

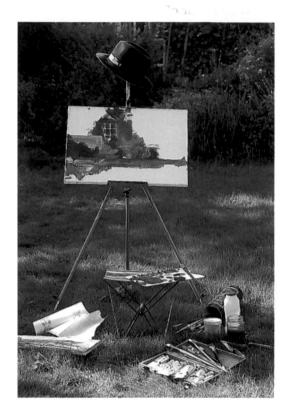

A lightweight, portable easel and folding stool ensure comfort when working outdoors. Take screw-top jars for water and a moist palette or water spray and clingfilm to help keep the colours moist in warm weather. Suitable containers will protect paints and brushes; the right clothing will protect you. Take warm clothes for the cold, and a hat or sunshade for the heat.

A position which is sheltered and shady at the start of the day inevitably becomes exposed as the sun moves. Painting in the sunshine sounds idyllic, but in reality it is uncomfortable and dangerous to work outdoors in a stationary position with the sun beating down on your head.

Conversely, a sunny morning can all too often be followed by a cold, drizzly afternoon and the hat is needed to keep your head dry.

THE CHANGING LANDSCAPE

Working out of doors offers the most direct approach to landscape painting. Yet the very things which make landscape so attractive and fascinating are almost the most problematical. Everything around us is on the move.

Clouds in the sky are constantly shifting. Light can change in an instant, totally altering the colours and affecting the tones of the subject.

To capture the constantly changing scene is a rewarding and stimulating challenge, but the artist must work quickly with the minimum of detail.

COLOUR SKETCHING

Lots of disposable painting surfaces are better than one or two specially primed boards or canvases.

A sketchbook of sturdy cartridge paper or a pad of acrylic paper is ideal. Working with a larger brush than normal makes for a broader, more spontaneous approach and discourages spending time on detail.

Armed thus, the acrylic landscape artist can tackle the subject with confidence. A series of colour sketches of a changing sky, for instance, can be executed almost as quickly as the clouds themselves move. There may be a high failure rate, but the rapid paintings will reflect the freshness and spontaneity of the subject.

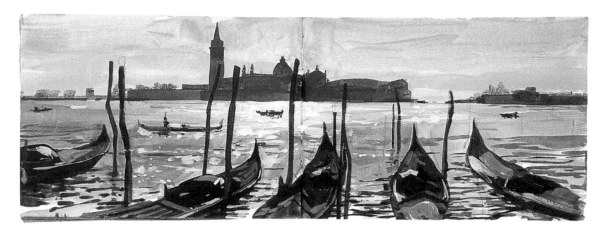

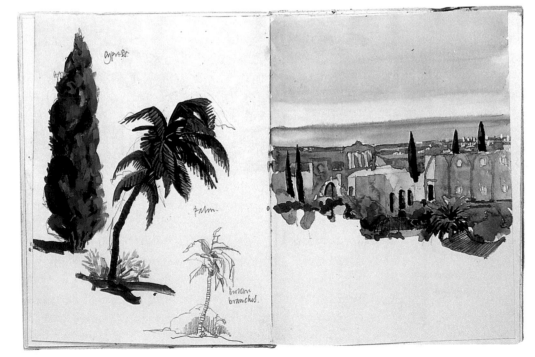

Sketchbooks are useful for reference drawings and quick sketches. Small books will slip easily into the pocket. Books with paper sturdy enough to take acrylic paints are good for colour notes.

Colour

There is no such thing as a standard palette. Each artist develops a personal selection of colours, to which he or she will often make changes and additions depending on subject, light and mood.

However, for every artist there has to be a starting point. The basic palette shown here offers a good spread of some of the most useful colours. They are all you need to complete the projects in this book.

However, this selection is not a magic prescription. As you become familiar with acrylics and the range of colours available, you will inevitably want to branch out and make changes.

Aims

- To understand basic colour theory and how to put this to practical use
- To gain a 'hands on' knowledge of mixing colours
- To choose a basic palette and be able to mix an extensive range of colours from this basic selection
- To lay out the palette and be able to mix colours in a systematic way

BLACK AND WHITE

The most obvious omission from the basic palette is black. It is debatable, but black is considered unnecessary by many artists.

They argue that black equivalents can be mixed from other dark colours, and a mixed 'black' is more interesting and in greater harmony with the rest of the painting than manufactured black.

This is often true, but a more important reason for the exclusion of black at this stage is that too much black in colour mixing makes the whole painting look muddy.

While the simplest way of mixing a dark version of any colour is to add a little black, this can easily be overdone. And if all the dark colours are achieved in this way, the whole picture ends up looking grey.

White, on the other hand, is essential – especially if you apply paint thickly. Thin colour can be diluted so that the white paper or canvas shows through to lighten the colours. But as a general rule you will need white, not only to make colours paler, but also as an irreplaceable pigment for painting the whites in the subject.

You will undoubtedly use more titanium white than anything else, so it is a good idea to buy a bigger tube at the outset.

TINTING AND COVERING STRENGTH

Some pigments are stronger than others and are therefore more effective in mixtures. With very strong pigments, a little goes a long way and these can be intrusive in a painting if overused.

A little practice at mixing colours will soon familiarise you with the relative tinting strength of each pigment. Among the strongest colours in the basic palette are alizarin crimson, viridian, burnt umber, phthalo blue and the cadmium colours.

In addition, some pigments are naturally more opaque than others. Such colours have a good covering capacity when painted over others. But even when very diluted, opaque pigments never appear transparent but will always retain a cloudy appearance.

Conversely, transparent pigments are beautifully clear when diluted but have a poor covering capacity. To obliterate underlying colours, paints made with transparent pigments need to be applied very thickly.

Opposite
BASIC PALETTE
The 13 colours shown here represent the basic palette – a recommended selection with which to start. They are the colours used for the projects in this workbook.

Payne's grey Many artists rely on Payne's grey a great deal, particularly those who do not use black. It has a weak tinting strength.

Raw umber A natural yellow-brown, sometimes used instead of black. It is especially effective as such when mixed with Payne's grey.

Burnt umber Warmer and more opaque than raw umber, burnt umber is a versatile mixer when used to create a range of rich, warm tones.

Yellow ochre A popular opaque colour in landscapes when it is often mixed with Payne's grey or blues to create muted greens.

Cadmium yellow A vivid, opaque yellow which comes in three tones.

Lemon yellow A clear, acidic yellow which is useful for mixing powerful greens and oranges. It is transparent with a rather weak tinting power.

Sap green Popular with landscape painters; a natural green often used unmixed.

Viridian A powerful colour with good tinting capacity. On its own viridian is overpowering, but is useful for mixing landscape greens.

Cerulean blue A permanent opaque blue popular for skies, especially in Mediterranean landscapes.

Phthalo blue A vivid colour with a powerful tinting strength, phthalo blue is very transparent.

Alizarin crimson A dark, brilliant red which is one of the most transparent colours on the palette. Alizarin can overpower other colours if overused.

Cadmium red A strong primary colour which comes in three tones. Cadmium red medium is to be found on almost every artist's palette.

Titanium white The only available acrylic white. Titanium white has good covering power.

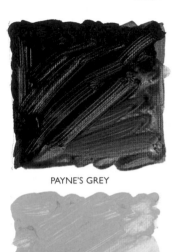

PAYNE'S GREY

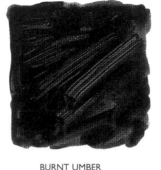

RAW UMBER

BURNT UMBER

YELLOW OCHRE

CADMIUM YELLOW

LEMON YELLOW

SAP GREEN

VIRIDIAN

CERULEAN BLUE

PHTHALO BLUE

ALIZARIN CRIMSON

CADMIUM RED

TITANIUM WHITE

MIXING COLOUR

A basic knowledge of colour is necessary for all artists, and the only effective way to learn about mixing colours is by trial and error and experience.

Most colour theory is based on the pure colours of the spectrum – red, orange, yellow, green, blue, indigo and violet. These bright, luminous colours are the colours we see in a rainbow and the product of light. When two spectrum colours are combined the resulting mixture is equally bright. Thus spectrum orange is a vivid, bright orange; spectrum green is a brilliant green, and so on.

The basis of colour mixing for the artist is the colour wheel, which is a simplified version of the spectrum, without the indigo. It is usually divided into six sections – red, yellow and blue, known as the primaries (which cannot be mixed from any other colour); between the primaries are colours mixed from these – orange, green and violet, known as the secondaries.

The acrylic equivalents of the spectrum primaries are generally accepted as being cadmium red medium, cadmium yellow medium and phthalo blue.

However, artists' paints are made from pigments, not from light, and they do not mix in the same way that the colours of the spectrum mix. We know that red and yellow make orange, blue and yellow make green, and blue and red make violet. But try mixing these in acrylic paints. The results will be disappointing – a dull orange, a dirty green, a muddy violet.

PRACTICAL MIXING

In order to get brighter versions of the secondary colours, try making a 'practical' colour wheel – a wheel which works for mixing paint colours rather than the colours of the spectrum. For example, the practical wheel shown here starts with a warm and cool version of each of the primaries. The yellows are cadmium and lemon; the reds are cadmium and alizarin crimson; and the blues are cerulean and phthalo. From these can be mixed a better violet and a brighter orange and green.

Only by mixing for yourself is it possible to discover how to obtain any colour you require from the selection on your palette. Continue to experiment and develop your own personal repertoire of colours.

The charts on the following pages show the result when each of the basic colours is mixed with an equal amount of every other colour on the palette. By varying the proportions in each mixture, or by adding small amounts of another colour, the range becomes almost infinite.

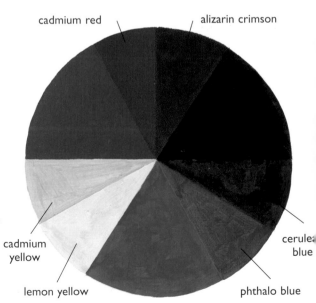

The classic colour wheel (*top*) is based on the spectrum, but with the colours bent round to form a circle. It shows the primary colours – red, yellow and blue – and the secondary colours – green, orange and violet. The inner wheel shows darker tones of the colours when mixed with black; the pale colours on the outside are those mixed with white.

The practical wheel contains two yellows, two blues and two reds. This choice of 'primaries' gives more scope for mixing brighter 'secondaries'.

red

orange

violet

yellow

blue

green

cadmium red

alizarin crimson

cadmium yellow

cerulean blue

lemon yellow

phthalo blue

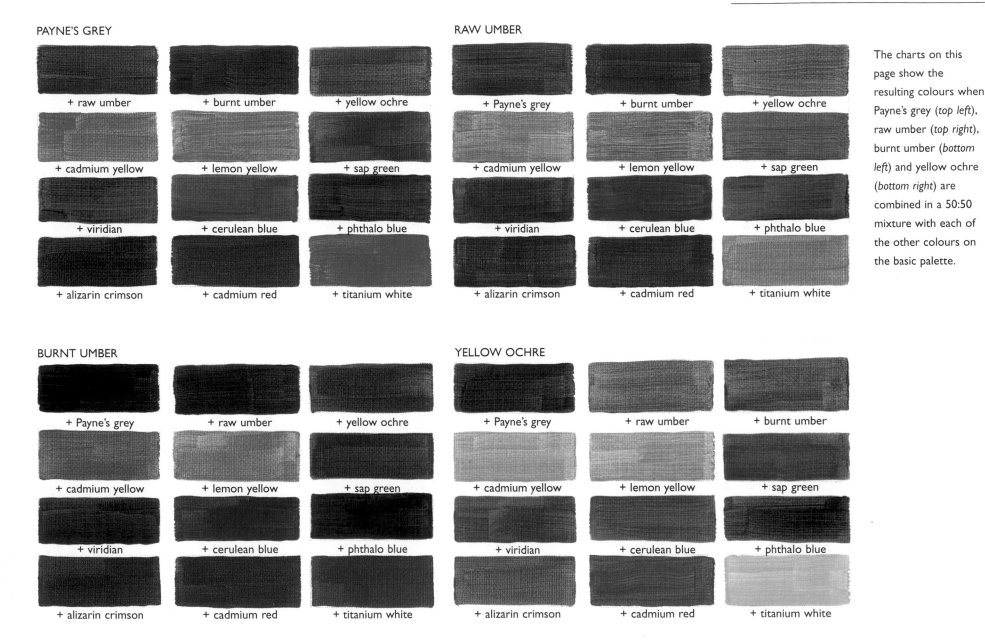

PAYNE'S GREY

+ raw umber	+ burnt umber	+ yellow ochre
+ cadmium yellow	+ lemon yellow	+ sap green
+ viridian	+ cerulean blue	+ phthalo blue
+ alizarin crimson	+ cadmium red	+ titanium white

RAW UMBER

+ Payne's grey	+ burnt umber	+ yellow ochre
+ cadmium yellow	+ lemon yellow	+ sap green
+ viridian	+ cerulean blue	+ phthalo blue
+ alizarin crimson	+ cadmium red	+ titanium white

BURNT UMBER

+ Payne's grey	+ raw umber	+ yellow ochre
+ cadmium yellow	+ lemon yellow	+ sap green
+ viridian	+ cerulean blue	+ phthalo blue
+ alizarin crimson	+ cadmium red	+ titanium white

YELLOW OCHRE

+ Payne's grey	+ raw umber	+ burnt umber
+ cadmium yellow	+ lemon yellow	+ sap green
+ viridian	+ cerulean blue	+ phthalo blue
+ alizarin crimson	+ cadmium red	+ titanium white

The charts on this page show the resulting colours when Payne's grey (*top left*), raw umber (*top right*), burnt umber (*bottom left*) and yellow ochre (*bottom right*) are combined in a 50:50 mixture with each of the other colours on the basic palette.

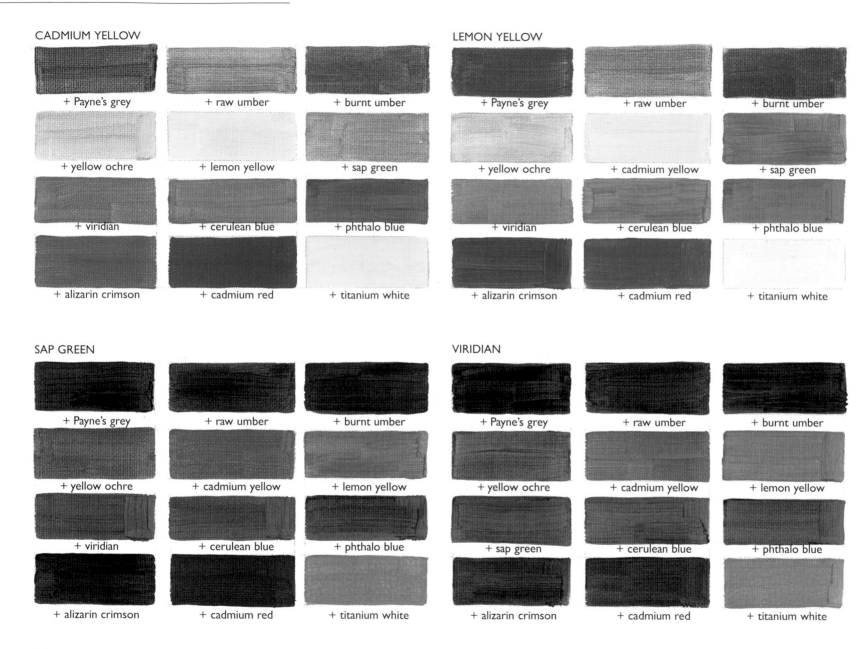

CADMIUM YELLOW

+ Payne's grey

+ raw umber

+ burnt umber

+ yellow ochre

+ lemon yellow

+ sap green

+ viridian

+ cerulean blue

+ phthalo blue

+ alizarin crimson

+ cadmium red

+ titanium white

LEMON YELLOW

+ Payne's grey

+ raw umber

+ burnt umber

+ yellow ochre

+ cadmium yellow

+ sap green

+ viridian

+ cerulean blue

+ phthalo blue

+ alizarin crimson

+ cadmium red

+ titanium white

SAP GREEN

+ Payne's grey

+ raw umber

+ burnt umber

+ yellow ochre

+ cadmium yellow

+ lemon yellow

+ viridian

+ cerulean blue

+ phthalo blue

+ alizarin crimson

+ cadmium red

+ titanium white

VIRIDIAN

+ Payne's grey

+ raw umber

+ burnt umber

+ yellow ochre

+ cadmium yellow

+ lemon yellow

+ sap green

+ cerulean blue

+ phthalo blue

+ alizarin crimson

+ cadmium red

+ titanium white

The charts on this page show the resulting colours when cadmium yellow (*top left*), lemon yellow (*top right*) sap green (*bottom left*) and viridian (*bottom right*) are combined in a 50:50 mixture with each of the other colours on the basic palette.

CERULEAN BLUE

| + Payne's grey | + raw umber | + burnt umber |

| + yellow ochre | + cadmium yellow | + lemon yellow |

| + sap green | + viridian | + phthalo blue |

| + alizarin crimson | + cadmium red | + titanium white |

PHTHALO BLUE

| + Payne's grey | + raw umber | + burnt umber |

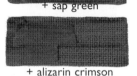
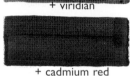
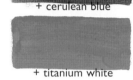

| + yellow ochre | + cadmium yellow | + lemon yellow |

| + sap green | + viridian | + cerulean blue |

| + alizarin crimson | + cadmium red | + titanium white |

The charts on this page show the resulting colours when cerulean blue (*top left*), phthalo blue (*top right*), alizarin crimson (*bottom left*) and cadmium red (*bottom right*) are combined in a 50:50 mixture with each of the other colours on the basic palette.

ALIZARIN CRIMSON

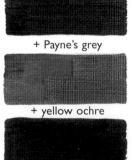
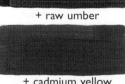
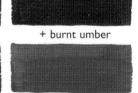

| + Payne's grey | + raw umber | + burnt umber |

| + yellow ochre | + cadmium yellow | + lemon yellow |

| + sap green | + viridian | + cerulean blue |

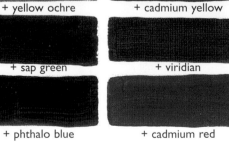
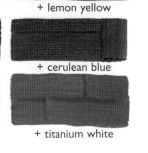

| + phthalo blue | + cadmium red | + titanium white |

CADMIUM RED

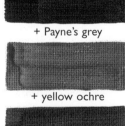
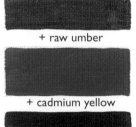
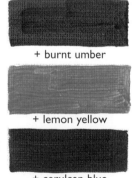

| + Payne's grey | + raw umber | + burnt umber |

| + yellow ochre | + cadmium yellow | + lemon yellow |

| + sap green | + viridian | + cerulean blue |

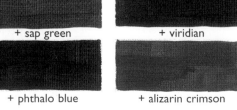

| + phthalo blue | + alizarin crimson | + titanium white |

PLANNING THE PALETTE

One of the most important stages when getting ready to paint is the preparation of the palette – choosing the colours and squeezing out the paints. To the more experienced artist, this procedure comes automatically and may seem obvious. But to the newcomer to acrylics, it is not always easy to determine how much colour to squeeze out or where to put the colours on the palette.

HOW MUCH PAINT?
Obviously the amount of each colour depends very much on the size of the painting and brushes. Also, a subject with a dominant colour scheme will require more of certain colours than others.

Because acrylic dries quickly, it is always better to squeeze out less paint than is actually needed. Colour can always be replenished, and the addition of clean paint will freshen up the colours on a used palette and also keep the paint soft and workable.

Most of the project paintings in this book are small to medium in size, so colour quantities should be judged accordingly. The paints squeezed out on the palettes in the photographs can be used as an approximate initial guide.

Inevitably, artists use lots of white and it is likely you will need at least twice as much white as any other colour.

ORDER OF COLOURS
Squeeze out the colours as close to the edge of the palette as is practicable. Leave a little space between the paint and the rim. This allows you to scoop up a brushload of colour without pushing the rest of the paint off the edge of the palette and making a mess.

Most artists squeeze out their colours in the same order on the palette each time they start work. There are two reasons for this. Firstly, any dry underlying colour will be the same as the new colour squeezed on top, so avoiding confusion.

The second reason is that a painter gets used to finding colours in the same place, and goes automatically to the right place on the palette to get a particular colour. Apart from saving time, this is especially useful with colours which look similar when newly squeezed, such as black, darker blues and some of the earth colours.

MIXING ON THE PALETTE
Inevitably colour mixtures become confused on the palette. Mixtures evolve and tend to overlap, especially in the later stages of a painting. Although the judicious use of one mixture as a basis for the next can create colour harmony in the painting, this can be overdone – especially by the inexperienced. It is all too easy to end up with a homogeneous grey palette and a muddy painting.

As far as possible try to keep the mixtures separate on the palette, at least until colour mixing becomes familiar.

Squeeze out colours on the palette in the same order each time you paint. This way you will be able to go straight to the colour you want without first having to search the palette. Here the basic palette colours are laid out in the order of the spectrum from white through to the reds.

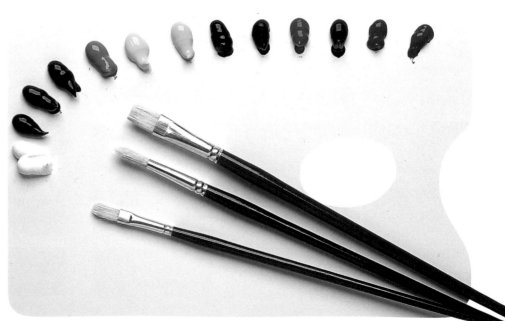

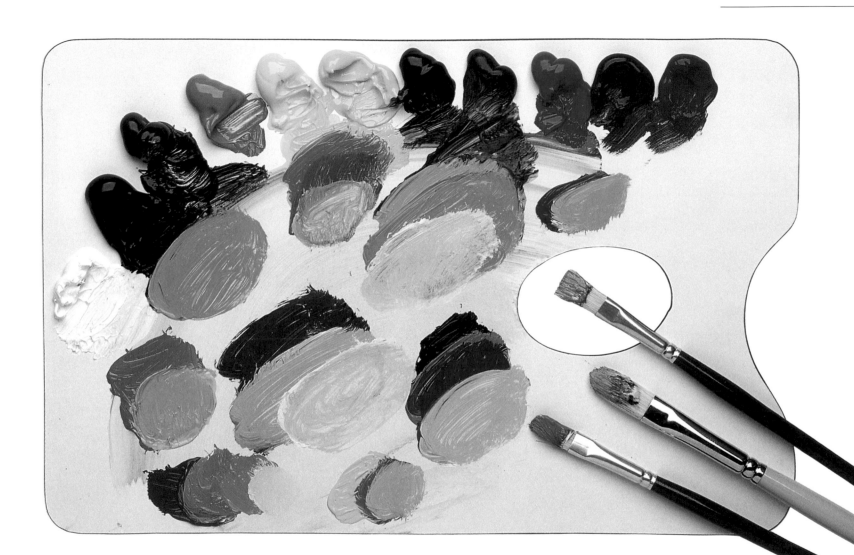

A well-ordered palette with colour mixtures kept separate from the laid out paints. When the palette becomes overcrowded or you reach a natural break in the painting, remove some or all of the mixtures by wiping the palette with a damp cloth. Moist, clean colours can be left intact and re-used.

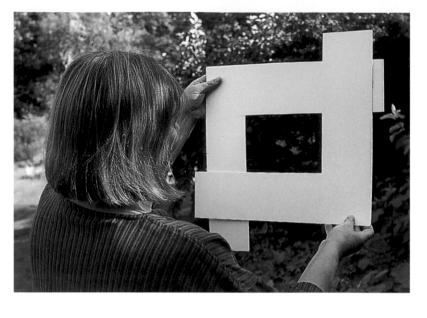

LESSON TWO

Getting Started

It is quite possible to spend as much time agonising over what to paint as it does to paint a picture. And all the time spent is often to no avail because ultimately it is the approach to the subject which is important, not the subject itself. In fact, almost any subject can be made interesting so long as you approach it in the right way.

Whether you are painting a still life, a landscape or a person, it is quite feasible to paint numerous pictures from the same spot and produce a different painting every time. The possibilities are endless.

Aims

- To choose a subject and to use viewfinders for finding the best proportion and composition for the subject
- To plan the painting in advance by making small colour sketches and preliminary drawings
- To paint loosely, so avoiding a common beginners' tendency to overwork the painting
- To start the painting by making an outline drawing in paint or pencil

SELECTING THE SUBJECT

When in doubt, sit down in front of any likely subject and consider the options. Unlike the lens of a camera, the human eye is not designed to select a perfectly rectangular or square composition from a shapeless scene or group of objects, so you must devise other ways.

To help visualise how the subject will look in a painting, cut two L-shaped brackets and put them together to form a rectangle.

Hold this rectangle up to the subject and use it as a viewfinder. It represents a possible painting, and by moving it around you can decide which compositions you like best and where the edges of the painting will be. The proportions can be altered by adjusting the brackets.

If you already have a canvas or board, cut a 'window' out of card to the same proportions as the painting surface and use this instead of the adjustable brackets.

THINGS TO AVOID

A composition is simply an arrangement of colours and shapes. This is largely a matter of personal choice and common sense, but there are a few pitfalls to watch out for.

Traditionally, a successful composition is one which holds the viewer's attention in the main picture area. In rectangular and square pictures it is sensible, therefore, to avoid placing important elements of the subject in corners of the picture.

Unless you have deliberately chosen to do otherwise, it is also a good idea to avoid compositions which are totally symmetrical. For example, a horizon line which divides the picture into two equal halves is unnatural and can be distracting to look at. A vertical line or shape down the centre of a composition may have an equally negative effect.

Cut two L-shaped brackets from a piece of card. Place the two together to form a rectangular viewer through which to look at the subject. Change the proportion and position of the rectangle until you find a composition you like.

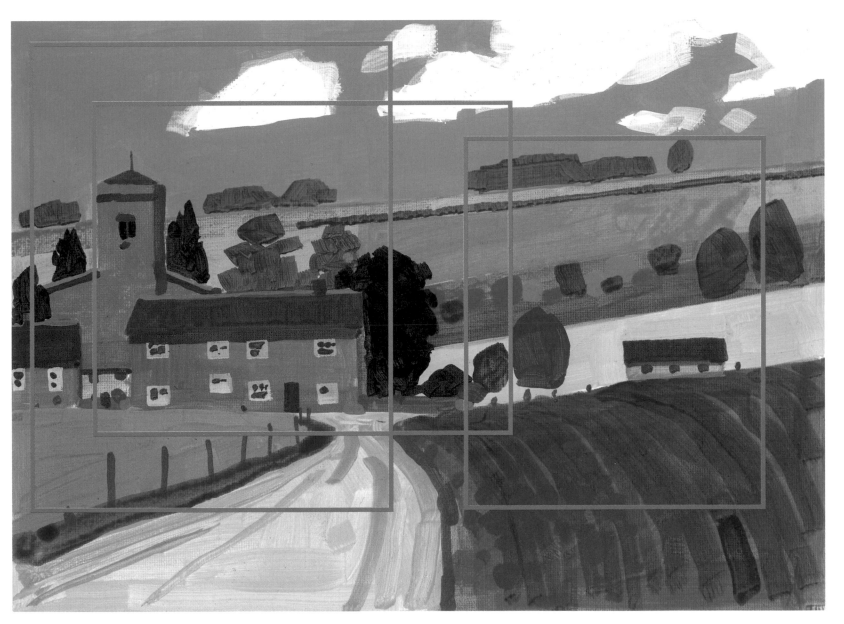

A number of compositions can be found in a single subject. This village landscape painting could have been painted in several equally attractive ways.

MINI SKETCHES

Simply by looking at a subject through a hole cut in a piece of card, we know there are a great number of perfectly acceptable compositions within the same subject. Even so, it may not be easy to visualise how these compositions will look when you have created them as paintings.

Before starting a painting, it is sometimes a good idea to make a series of small, rapid sketches to help you visualise the final composition. These may take the form of drawings, or small colour sketches (often referred to as thumbnail sketches) like the ones here. Some artists do both, making lots of tiny rough drawings, then selecting the best ones to try out in colour.

This is not as time-consuming as it sounds. Your sketches are a means to an end. They need include no detail and do not have to look like finished drawings. You are looking for the best arrangement of shapes, or shapes and colours, and it does not matter if the subject is unrecognisable to anyone except yourself.

However, it is surprising how many artists say they often prefer a rough sketch to the final painting, simply because it contains a freshness and spontaneity which the completed picture lacks.

START WITH A STILL LIFE

Look at the series of colour mini sketches on this page which experiment with various ways of tackling a collection of colourful kitchen items.

The objects are moved around and arranged differently in each picture. Each arrangement is viewed from several angles, tried in various positions within both rectangular and square picture areas, and depicted as small or large in relation to the space around it.

Apart from moving around the arrangement, you can also view the subject from different heights.

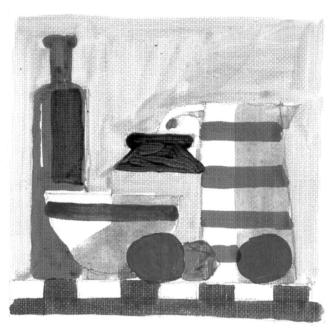

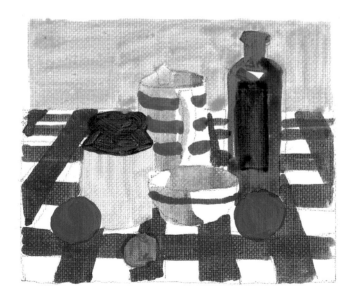

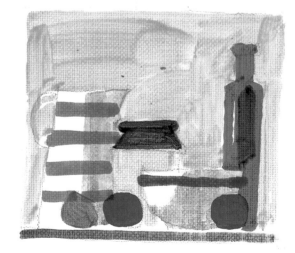

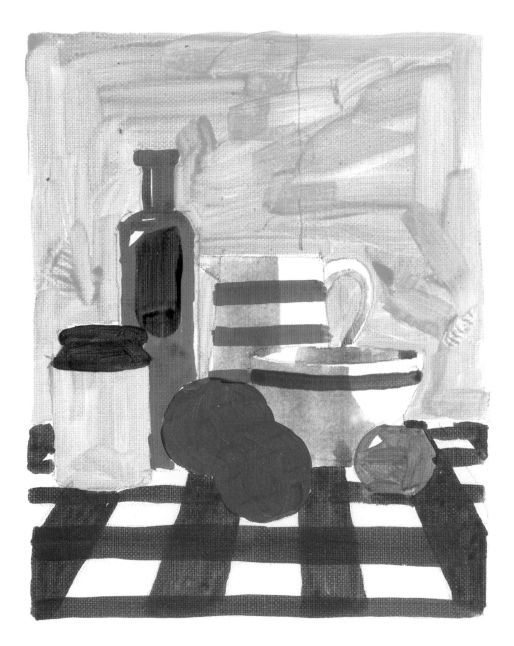

Thumbnail colour sketches for a still-life painting. Trying out alternatives on a small scale will enable you to make decisions about a larger scale painting. Whatever the subject, it is important not to neglect the space surrounding the central elements of a composition. For example, both the background wall and the red and white table cloth are important elements in all of these sketches. The relationship of foreground to background varies from picture to picture, but in each case these surrounding areas form an important part of the composition.

LOOSEN UP

Understandably, beginners are often inhibited and nervous about their ability to draw and paint. There is a tendency to 'play safe', to work on a small scale with tiny brushes. Instead of concentrating on the overall image, the newcomer feels that if enough detail is included the painting will look realistic, and this will somehow disguise and compensate for any lack of experience.

In fact the opposite is true. A realistic or naturalistic painting does not necessarily depend on detail. Realism depends on accuracy and observation, on how the colours relate to each other. A realistic impression of the subject can be achieved with very little detail.

BIG BRUSH PAINTING

Prevent your work from becoming too tight and fiddly by working with a large brush. Not only is this an excellent loosening up exercise before you start on a final painting, but the loose paintings can be enormously helpful as reference.

Before embarking on a still life or landscape, first do a quick painting of the subject, using a small decorating brush or the largest artists' brush you have. In these circumstances, detail becomes impossible. You are forced to pay attention to other things, particularly to colour and shape. Consequently, these elements will be more accurately established in relation to each other as a result of the broad brushstrokes.

For example, a large flat brush was used for the arrangement of fruit, and a small decorating brush for the rural landscape shown here. The brushes were too large and clumsy to paint obvious details, such as highlights on the fruit and foliage textures in the landscape. Instead, the artist concentrated on establishing the overall shapes and the differences between the main areas of colour.

When it comes to painting more finished pictures of these subjects the artist has ready reference for the main colours and knows exactly how each colour is mixed.

A still life painted with a large brush is a helpful two-minute loosening up exercise before you move on to start the painting.

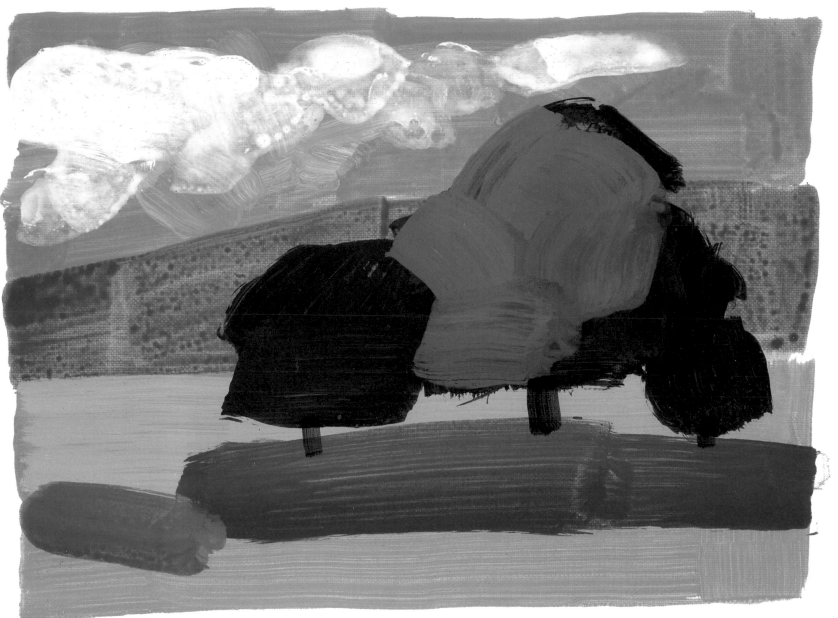

Painted with a decorating brush, this rapid landscape sketch captures the main elements of the subject.

STARTING THE PAINTING

The canvas is stretched, the subject chosen. What next? There are various ways of starting a painting, but the most usual is to begin with a light drawing on the painting surface before starting to apply colour. This need not be detailed. A simple outline is usually sufficient to act as a guide for the paint. In most paintings the initial drawing is eventually obliterated by the solid colour.

For the sake of clarity, all the painting projects in this workbook are started with an outline drawing using carbon pencil. However, there are alternatives and you should try starting at least one or two of the projects with an outline drawing in charcoal or in paint.

The only mediums which are not compatible with acrylics are those containing wax or oil, such as wax crayons and oil pastels.

PAINTED OUTLINES

A thin mixture of acrylic colour is an alternative medium for the outline drawing. In this case, the coloured drawing is often deliberately allowed to show through in the finished painting and becomes a unifying or decorative element in the completed picture. Choose a colour which complements the colours in the subject.

SOLID COLOUR

Another way of starting a painting is introduced in The Olive Grove project on page 102. This starts with a minimal outline which is followed immediately by loose blocks of colour.

An even more direct start is to dispense with any outline at all. Thin colour dries quickly, allowing you to work over the first stage and develop the painting, as in the early stages of a sunset landscape on the opposite page.

You can start with a painted outline instead of a pencil drawing. Choose a colour which complements or harmonises with the subject colours.

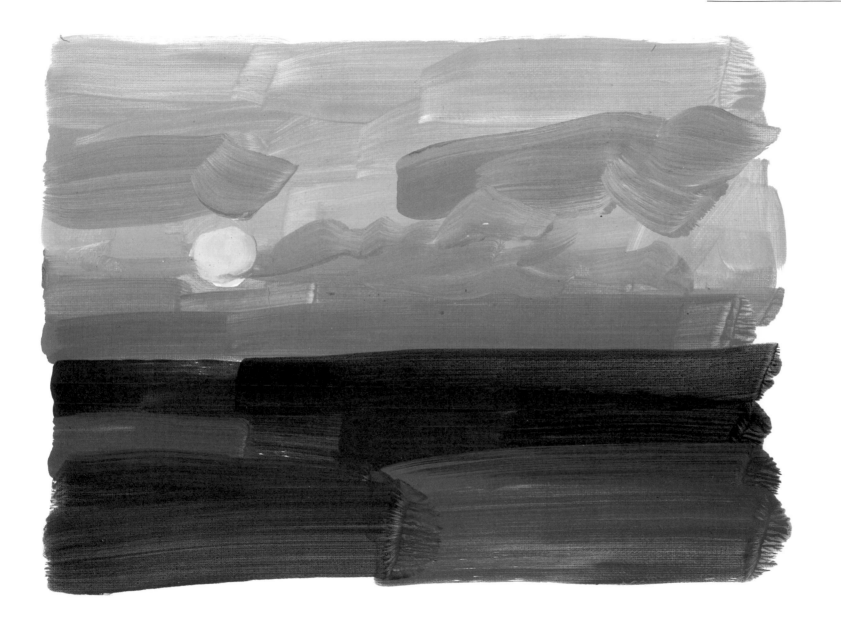

The first stages of a sunset landscape using solid colour instead of a drawn outline.

KEEP IT SIMPLE

There is no such thing as a simple subject, but there is one very good way of making any subject much easier to paint.

Try the 'simplified' approach, choosing a single tree as your subject, as in this example.

Initially, the tree appears dauntingly difficult – a complex arrangement of branches shrouded by a mass of foliage. A thousand patches of background sky flicker confusingly through the leaves and branches.

Most of this is what we 'know' to be there, not what we can actually see. Even if we could see every detail, it would not be necessary to paint each tiny leaf and twig. The aim is to simplify the tree by establishing the main areas of tone and colour.

By simplifying the subject not only is difficult detail eliminated but – more importantly – it also becomes possible to concentrate on the basic structure of the subject without worrying about distracting details and surface patterns. Eventually you may wish to take the painting a step further and add more detail, but even so the best approach is to start by establishing the subject in simple terms.

BEGIN WITH A DRAWING

Make a drawing like the one shown here. A soft drawing pencil has been used, but charcoal, ball-point pen, or any other drawing implement will do equally well.

Draw only what you can actually see, not what you know is there. This is normally the larger branches of the tree surrounded by large masses of foliage with soft, feathery outlines. Leaves cannot be identified individually, but appear as areas of texture which can be indicated as loose scribbles or criss-cross marks.

Try to establish the areas of light and shade. By looking at the tree through half-closed eyes, outlines appear hazier, and local colour less dominant. This makes the lights and darks much easier to distinguish.

Use bold, heavy strokes to establish the dark shadows in the foliage. For paler areas and patches of bright sunlight, apply lighter strokes or simply leave patches of white paper.

SIMPLIFIED COLOUR

Foliage in this painting is simplified and painted in just two tones – light green and dark green. The paler tone is mixed from sap green and white, the darker tone from sap green and raw umber.

Refer to your drawing when deciding

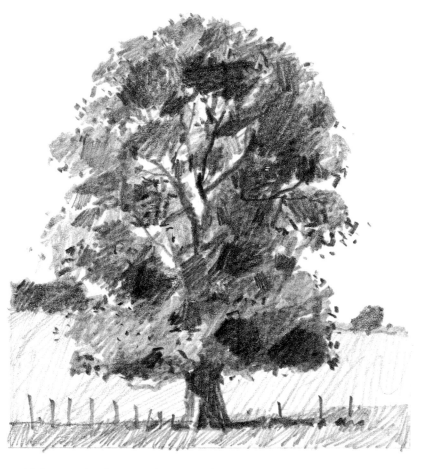

which areas in the painting to make light and which to make dark. All shadows and partially shaded areas on the drawing are simplified and painted as a single colour in the painting – dark green. Similarly, all the pale tones and sunlit foliage are painted in the same light green.

THE DRAWING
A 4B graphite pencil was used for this tonal drawing. It shows areas of light and shadow and all *visible* detail.

AN IDEAL STARTING POINT

The simplified colours of this tree painting are obviously extremely limited. Just two tones of green are used to describe all the foliage, a single blue for the sky, a single yellow for the field of corn, and so on. Only five colours were used for the mixes – phthalo blue, white, sap green, cadmium yellow and raw umber.

It is true to say that almost all acrylic artists simplify the colours of their subjects to some extent. In particular, many find simplification a useful starting point, a first stage before going on to develop the subject in more detail.

As can be seen from the painting on pages 102-107, the quick-drying nature of acrylic paints makes them ideal for this approach. It allows you to apply layer upon layer of thin paint in quick succession with very little drying time needed in between coats.

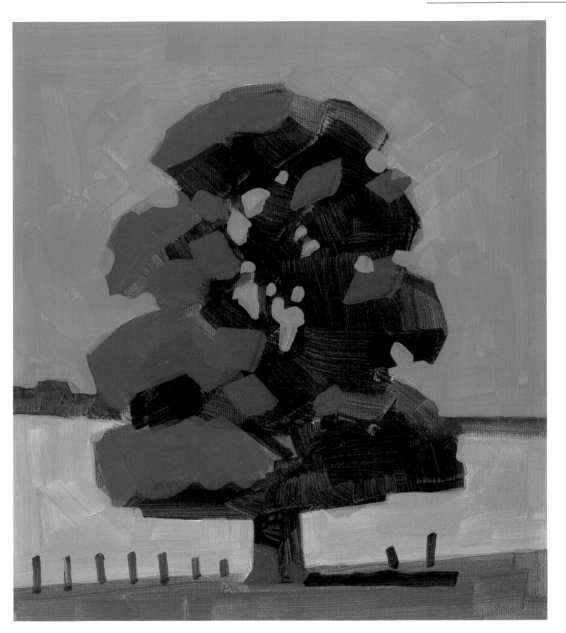

THE PAINTING

The tree was painted first. The closely observed branches, leaves and textures of the drawing are replaced with broad strokes of colour. Shapes are simplified, and the light and shade of the foliage is simplified as two tones of green. The background sky and fields were painted up to the tree shape, and patches of sky dabbed onto the foliage.

The sky is mixed from phthalo blue and white; pale foliage is sap green and white; dark foliage is sap green and raw umber; the field is yellow ochre and white; the foreground grass is sap green and cadmium yellow.

STILL LIFE WITH FRUIT AND JUG

Our first project starts with loose washes of thin colour. The painting is then continued in stages, gradually introducing the lightest and darkest tones, using thicker and thicker paint.

This may sound complicated but it is actually very simple, and do not worry if your colours are not exactly the same as those used here. No two colour mixtures are exactly the same.

FEEL FREE

This is a good first project because the initial paint marks are very sketchy and loose. In other words, you need not feel too inhibited about being messy in the early stages!

Provided you start with a reasonably accurate drawing, colour can be applied freely using quite large brushes.

The loose colour washes in the first stage correspond approximately to the colours of the subject – yellow lemons, green apples, and so on. Do not be too fussy about the accuracy of the actual colours, although it is helpful to establish the light and dark colours correctly in relation to each other. For example, the jug and background are fairly pale compared with the dark greyish purple of the shadows.

Always allow the paint to dry between each stage – if you try to paint on to wet colour, you will simply wipe off the first layer and it becomes impossible to build up the colours.

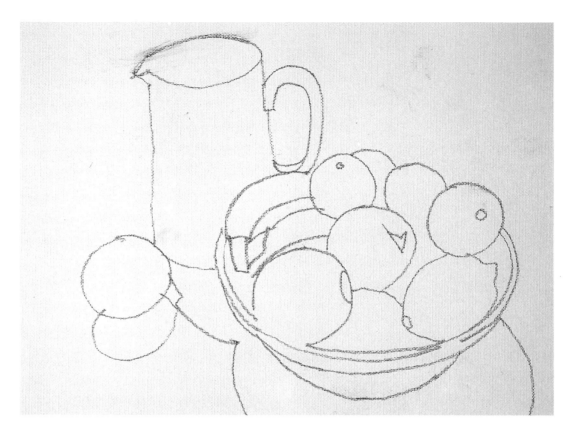

Palette

TITANIUM WHITE

CADMIUM YELLOW

YELLOW OCHRE

CADMIUM RED

SAP GREEN

PHTHALO BLUE

PAYNE'S GREY

For this painting you will need:
Palette colours
Brushes: a 12mm (½in) and 6mm (¼in) flat
Sheet of Cryla paper 25x33cm (10x13in)
Carbon pencil for drawing

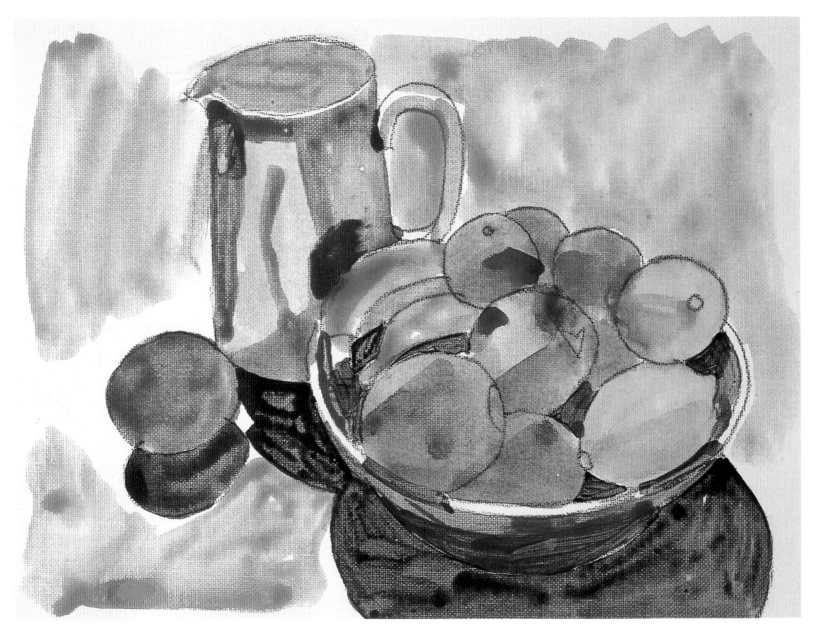

STEP 1

Mix yellow ochre and white with a lot of water and paint the background using the 12mm (½in) brush. With the same brush apply thin washes of colour to the rest of the subject. The oranges are cadmium red, cadmium yellow and yellow ochre; the apples, sap green and cadmium yellow; bananas, cadmium yellow and yellow ochre. Paint the jug in thin washes of Payne's grey with touches of cadmium yellow and cadmium red. The shadows are a dilute mixture of Payne's grey and cadmium red, the bowl, yellow ochre and Payne's grey.

STEP 2

For this stage, colours should be thicker and more opaque, so mix with less water. Still using the 12mm (½in) brush, lighten the background with a mixture of white, yellow ochre and a little cadmium red. Allow flecks of the first washy colour to show through to give a lively, broken effect. Strengthen the fruit and bowl using the same mixtures as before but with a little added Payne's grey for the shadows and a little white for areas catching the light. Paint the jug in neutral greys mixed from white, cadmium red, cadmium yellow and phthalo blue. Darken shadows with phthalo blue and cadmium red.

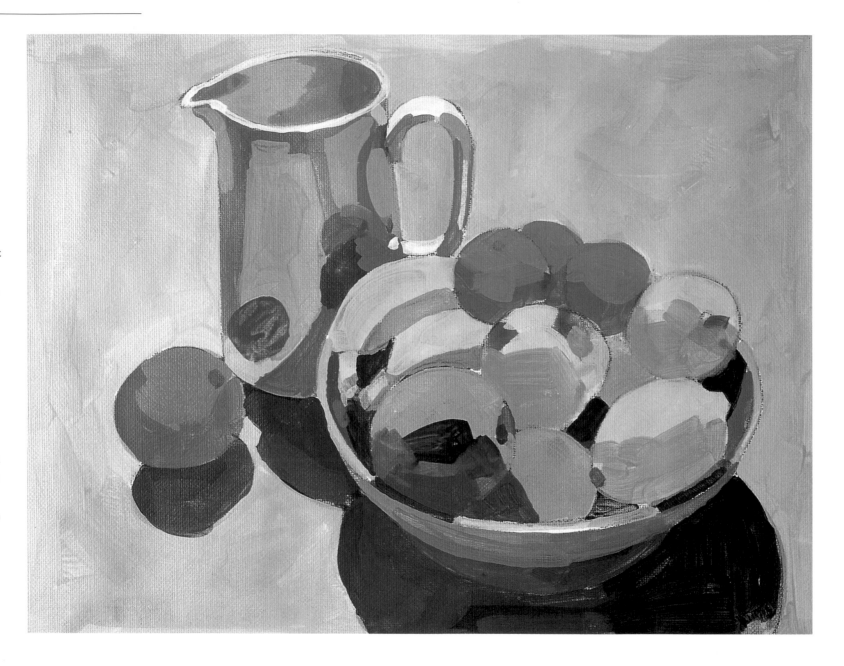

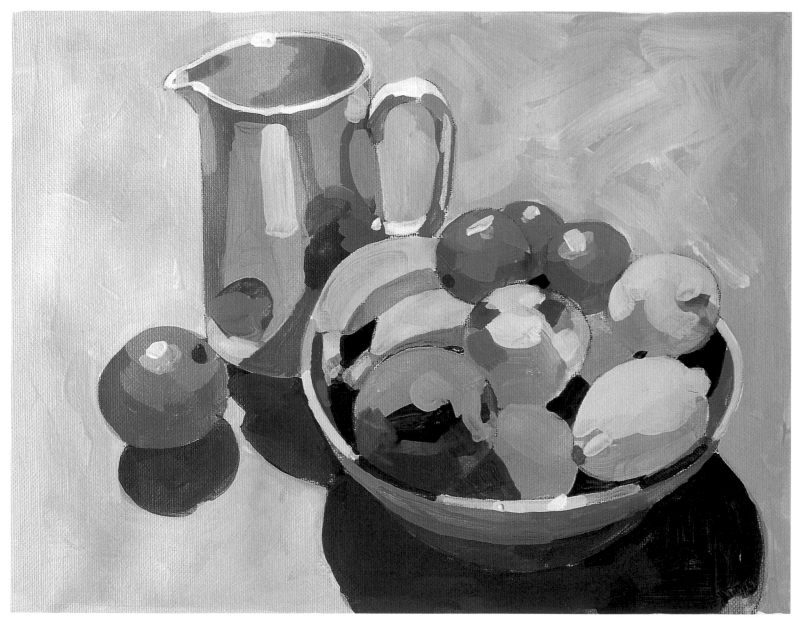

STEP 3

Finally, lighten the background using the same mixture as before but with added white. Again, allow flecks of underlying layers to show through to enliven the paint texture. Change to a 6mm (¼in) brush and add highlights to the fruit, bowl and jug using white with added touches of their colour. Darken the shadows under the bowl, jug and orange in deep purple mixed from phthalo blue, cadmium red and Payne's grey.

Creating Textures

Acrylics have no rival when it comes to creating stunning surface effects and textures. There are few restrictions. If you want to invent your own surface patterns, or to recreate the textures of the subject – rippling water, a sandy beach or any other natural or manufactured effect – you can do this easily with acrylic paints.

The only drawback is that textures can be overdone, and instead of providing a touch of visual interest each texture can end up by cancelling out the impact of its neighbour. The secret is to be selective. One or two selected areas of tactile or textural paint surface will enhance the picture. Too many can spoil it.

Aims

- To experiment and develop a repertoire of creative textures for use in paintings
- To introduce into paintings textures made with acrylic pastes and mediums
- To vary the paint texture by the addition of sand and other granular materials
- To exploit brushmarks to create interesting and lively surface textures

EXPERIMENT

Have fun discovering textural effects with acrylic paints and mediums before committing them to a painting. The more 'hands on' experience you have, the better you will understand their full potential and the more selective and creative you can be.

Paint can be applied thickly with a brush or palette knife and will then dry quickly enough for you to continue building it up in two or more layers. Scratching back into the wet paint will reveal underlying colours.

PASTES AND GELS

Texture pastes and gels increase the thickness of the paint which can be built up into what can only be described as a three-dimensional surface. And all manner of objects can be impressed into the wet paste to create imprinted patterns.

This is very satisfying and provides a useful insight into the potential of the medium. However, it is important to stop and think whether this is the effect you actually want in your paintings. Mediums should be used discerningly, as a means to an end and not an end in themselves.

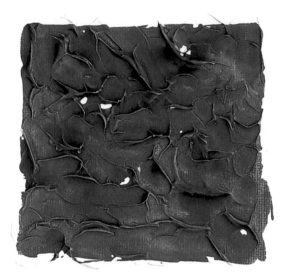

Modelling paste applied with a knife and painted over.

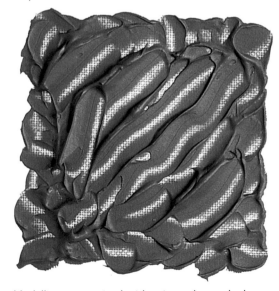

Modelling paste mixed with paint and scratched into with the end of a brush handle.

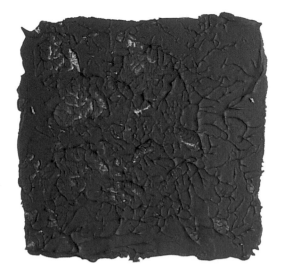

Imprinting into texture paste and paint with crinkled tin foil.

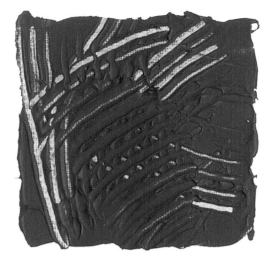

Combing into texture paste and paint.

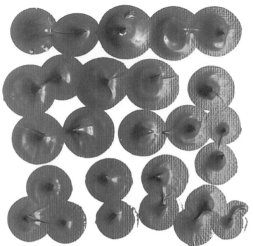

Paint dabbed directly from tube.

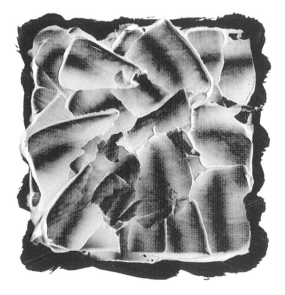

Texture paste applied with knife over dry paint.

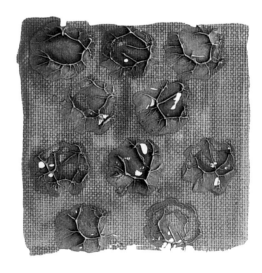

Texture paste dabbed on with finger and painted.

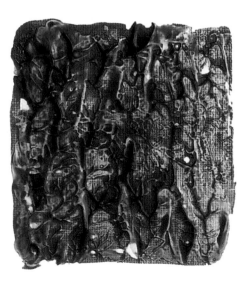

Gel medium stippled with flat edge of knife blade and painted over.

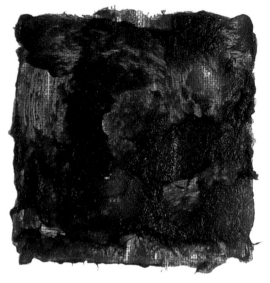

Sawdust mixed with paint.

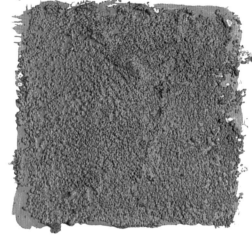

Sand mixed with matt medium and painted over.

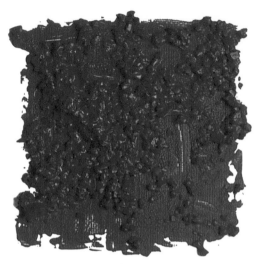

Rock salt mixed with paint.

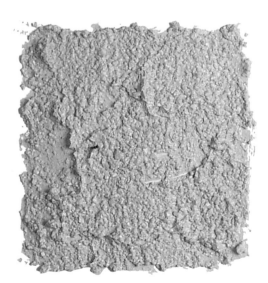

Sand mixed with paint.

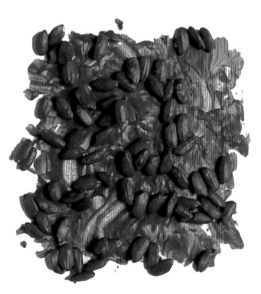

Rice mixed with paint.

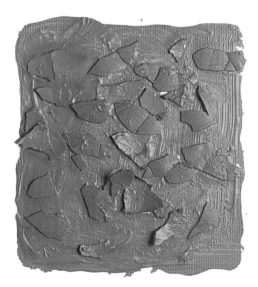

Eggshell stuck with gloss medium and painted.

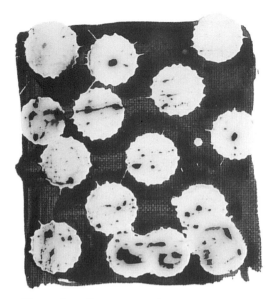

Drips of candle wax painted over.

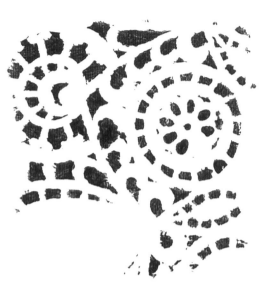

Paint over paper doiley used as stencil.

Heavy gel medium mixed with paint.

Additions of dry, inert substances lend their own textures to the paint. Sand, grit and other granular substances produce a coarse surface. Tissue, kitchen roll and other papers can be stuck down and painted over to give a characteristic crinkled effect.

Paint applied with muslin scrim.

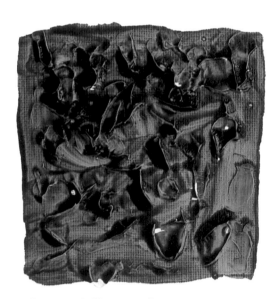

Decorator's filler painted over.

Paints mixed with matt medium overlaid by stippling.

BRUSHMARKS

Every paintbrush in the artist's studio plays a unique and creative role. Not only does the shape of each brush dictate the mark it will make, it also determines how much paint the bristles will hold.

Some brushes, such as flats, are very versatile and can be used for more than one purpose. Others, like the distinctive fans, are designed specifically to produce light, feathery marks but are not good general-purpose brushes.

BRUSH SHAPES

Rounds are the most universally used brushes – the sort provided with children's paintboxes. Swollen bristle heads hold a lot of paint, which means you can make unbroken, flowing lines without having to stop to reload the brush. The bristles are pointed and when used lightly can produce very fine lines; thicker lines are achieved with more pressure.

Flats are extremely versatile. The bristles, held in a flattened ferrule, are flexible with square ends. They can be used both for filling in areas of colour, and painting even or undulating lines. Painting with the side of the flattened bristle head creates a finer line.

Brights are similar to flats, but with shorter bristles. These are more rigid, and are generally favoured for applying paint thickly and for creating texture.

Filberts are a cross between a flat and a round. They have a slightly flattened ferrule and long, slightly tapering bristles. They are good all-round brushes, but especially useful for smooth blending of edges and undulating curves.

Fans have shallow, splayed bristles and are used mainly for softening hard edges and for blending two colours together.

BRUSHWORK

Successful brushwork is more dependent on the painter than the paintbrush. For fluid strokes and easy curves, paint from the elbow not the wrist; cramped, inhibited painting will produce similarly cramped strokes whichever brush you choose.

Above all, resist the temptation to buy every type of brush in the shop. Start with a few. You may eventually find you prefer one type to all others, and this is fine.

Many artists get used to using one type of brush for everything, regardless of its intended purpose. Often, an artist will get used to a particular brush and use it for years – sometimes until the bristles are almost worn to a stump. It is then reluctantly discarded and a new brush broken in to replace it.

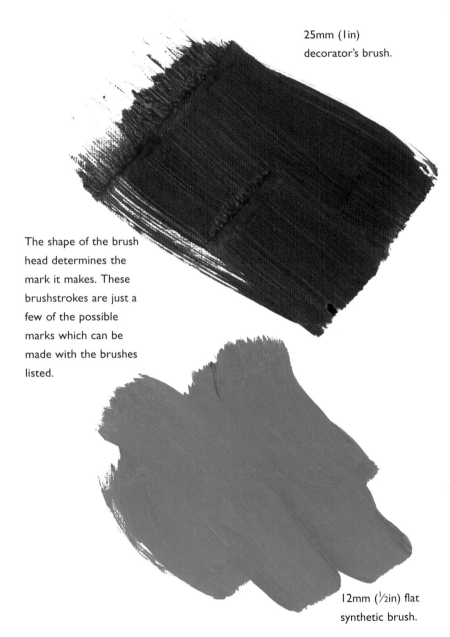

25mm (1in) decorator's brush.

The shape of the brush head determines the mark it makes. These brushstrokes are just a few of the possible marks which can be made with the brushes listed.

12mm (½in) flat synthetic brush.

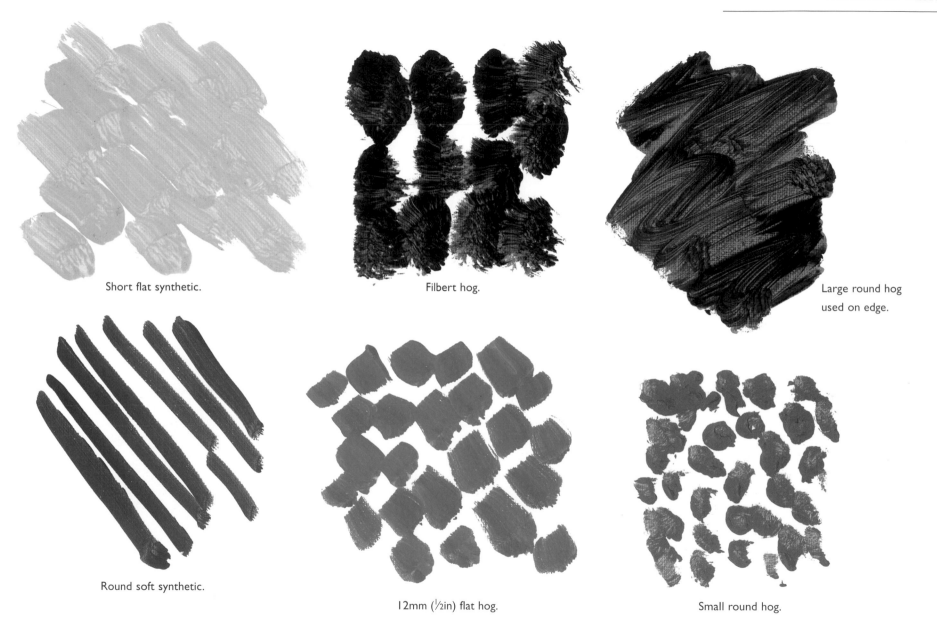

Short flat synthetic.

Filbert hog.

Large round hog
used on edge.

Round soft synthetic.

12mm (½in) flat hog.

Small round hog.

DRIED FLOWERS

Be selective with your acrylic textures. Choose one or two textural patterns and these will contrast effectively with adjacent areas of flat colour; overdo the textures, and the patterns cancel each other out and lose their impact.

Above all, be experimental and creative. The most effective textures are often the most unlikely ones. For example, the dark brown centres of these dried sunflowers are mixed with sand – not at all like the real flowers, but extremely striking nevertheless.

Dried flowers have very definite textures and this makes them an ideal choice for this project. However, textural painting does not depend entirely upon visible textures in the subject. You can brighten up any painting with a few lively textures – even if they are a figment of your imagination!

SURFACE VARIATIONS

The composition here is simple, brought to life with a few bold textures which capture exactly the dry, textural quality of the subject. Important variety is achieved by contrasting finely scratched lines with the granular effect of sand and the rugged bumpiness of acrylic texture paste.

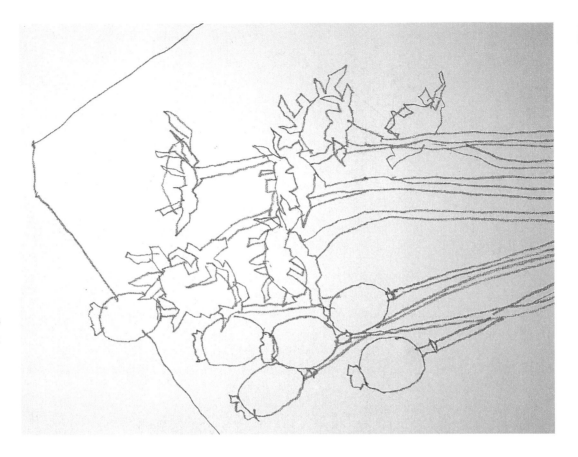

Like the linear marks on the sunflowers, most graffito textures are scratched into the paint while it is still wet. This involves a little forward planning. A scalpel and any other tools you might need should be to hand to avoid the paint drying while you go in search of a suitable implement.

For this painting you will need:
Palette colours
Brushes: a No.5 filbert, 12mm (½in) and 6mm (¼in) flats
Sheet of Cryla paper 28x35cm (11x14in)
Carbon pencil for drawing
Acrylic texture paste
Sand, scalpel
Carbon pencil for drawing

BURNT UMBER

RAW UMBER

YELLOW OCHRE

CADMIUM RED

ALIZARIN CRIMSON

PAYNE'S GREY

TITANIUM WHITE

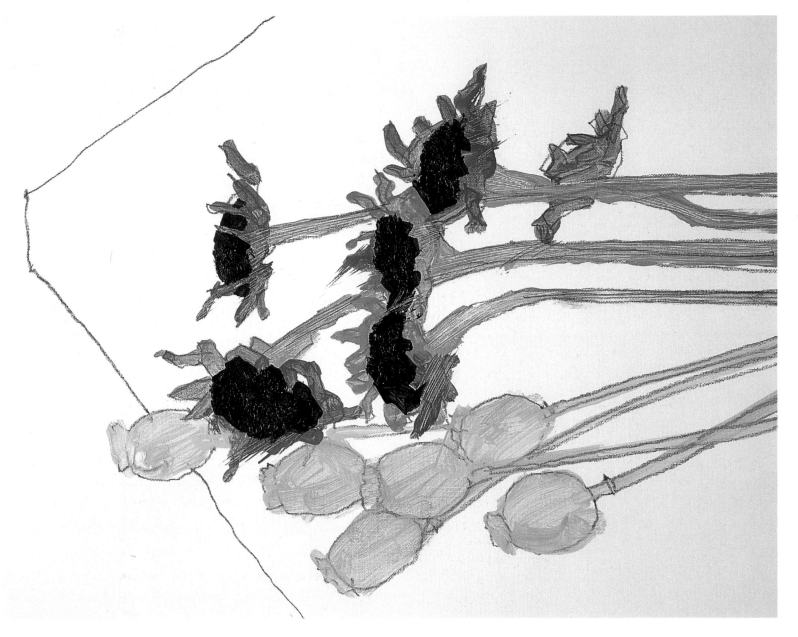

Using the filbert brush,
paint the poppy heads
and stems in a diluted
mixture of white,
burnt umber and
yellow ochre. Add a
little cadmium red to
the first mixture and
paint the sunflower
stems and petals.
Before this dries,
scratch the grooves
and texture into the
sunflowers. For the
dark centres of the
sunflowers, mix burnt
umber with Payne's
grey and add enough
sand to form a stiff
paste.

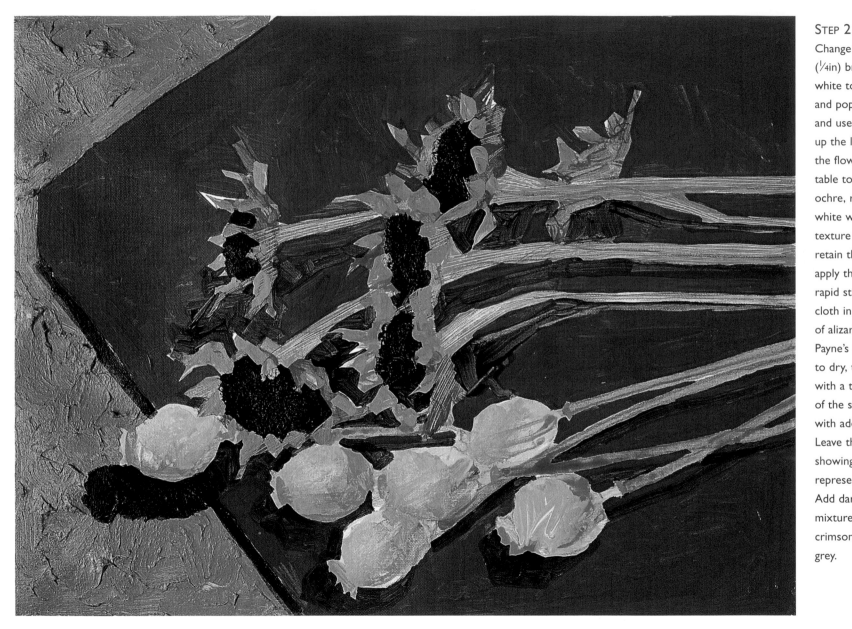

STEP 2

Change to the 6mm (¼in) brush. Add thick white to the sunflower and poppy mixtures and use this to build up the lighter tones on the flowers. For the table top, mix yellow ochre, raw umber and white with a little texture paste. To retain the texture, apply this in loose, rapid strokes. Paint the cloth in a thin mixture of alizarin crimson and Payne's grey. Allow this to dry, then paint over with a thicker mixture of the same colour with added white. Leave the undercolour showing through to represent the shadows. Add dark shadows in a mixture of alizarin crimson and Payne's grey.

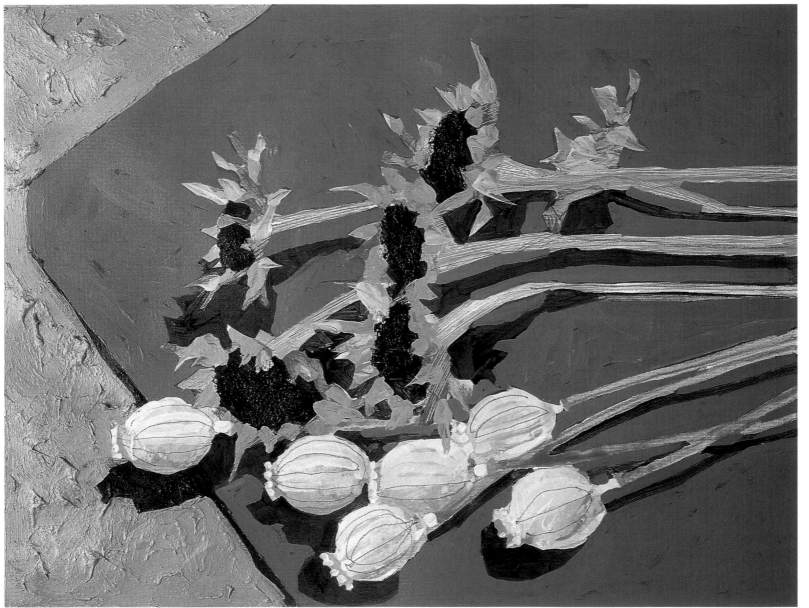

Mix yellow ochre and white to lighten the table area by loosely painting over the dry texture paste. Similarly, lighten the cloth by overpainting with the original colour with added white. Strengthen the shadows on the cloth with a thickish mixture of alizarin crimson and Payne's grey. Finally, use a pencil to draw the dried ridges on the poppy heads.

51

KNIFE MARKS

The paintbrush is the traditional tool of artists, but we now have a practical alternative, the knife.

In the past, oils have been the most popular painting medium. Oil colours dry slowly and thick paint is usually built up gradually, with each layer being allowed to dry partially before more paint is applied. Although oils are sometimes applied with a knife, the thickness of the colour is limited by the lengthy drying time which precludes very chunky effects. For this reason, artists have generally found brushes to be more useful than knives for oil painting techniques.

However, with acrylics there is no reason to feel confined to painting with a brush. The thick, buttery, quick-drying colours can also be applied with a knife to create broad swathes of flat paint, chunky ridges and a variety of other impasto effects.

Knife painting allows you to paint quickly, and the result can be character-istically fresh and spontaneous. The secret of successful knife painting is to work boldly with complete confidence. Keep the painting simple and know when to stop. It is not an approach suited to a lot of detail, and overworking will often result in muddy colours.

A painting may be worked exclusively with a knife. Alternatively, you can combine a variety of knife and brushmarks to achieve a wide range of textural effects.

WHICH KNIFE?

Colour can be applied with any flat-bladed knife, including palette knives and spatulas. But the easiest tool by far is the purpose-built painting knife. This has a cranked, or bent, handle rather like the handle of a builder's trowel. This handle allows the blade to be held at right angles to the painting surface, enabling the colour to be applied thickly and evenly. The cranked handle means the artist's hand can be held well clear of the canvas, minimising the risk of accidental scraping and smudging of wet paint.

Painting knives come in a wide variety of shapes and sizes. Long, flat blades are flexible and are excellent for applying broad areas of colour. Small diamond-shaped blades are better for smaller paintings and for making controlled marks.

PRACTISE FIRST

Like all painting techniques, applying colour with a knife is easy once you know how. But it does call for a little practice. The newcomer to acrylics must learn to apply the paint and then leave it alone. Resist the temptation to 'tidy up' the knife

marks or attempt to remove colour which looks too thick.

Impromptu marks and accidental effects all make a positive contribution to the finished painting, and you can easily destroy lively knife marks with too much meddling.

Before embarking on a complete painting try a few experiments. The basic knife marks shown here are each painted in a single colour, using paint directly from the tube. Each textured mark is made with the small diamond-shaped painting knife illustrated in the photograph, and the range includes all the techniques used in the landscape knife painting of the field of corn on the following pages.

A painting knife can be used instead of a brush to create areas of thick, flat colour. Scoop the undiluted colour from the palette with the underside of a painting knife and spread the paint evenly and smoothly across the canvas.

This knife was used to make all the marks on the opposite page.

Short, random strokes with scraped-back colour to reveal canvas texture.

Textural effect created using the pointed end of painting knife blade.

The edge of the knife is dipped in paint and dragged to create lines.

Knife marks are particularly useful in landscape painting. Experiment and develop your own repertoire of marks and textures similar to the ones shown here for use in future paintings. For example, scratched and linear marks applied vertically can create an impression of grass, harvested fields and reeds; horizontal strokes can be creatively adapted to describe the ripples and reflections on water.

The underside of the knife is dipped in paint and pressed onto the canvas.

An area of wet colour is scratched with the pointed end of the knife blade.

An area of wet colour stippled with paint on the underside of the painting knife.

FIELD OF CORN

Golden heads of corn and red poppies blowing in the breeze make this colourful knife painting appear like a scene from a picture book. And that is exactly what it is – a painting from an illustration found in an old travel guide. A few simple knife marks and thick colour bring the scene to life, creating a lively, textural painting from a printed photograph.

The important aspects of this project are the knife marks and textured paint, so do not worry too much about getting an accurate composition which matches exactly the one shown here. This composition is deliberately uncomplicated, so there is no need to start with a drawing. Simply begin by applying areas of colour with a knife.

This painting is done using a small diamond-shaped painting knife on a primed canvas-covered board measuring approximately 26 x 20cm (8 x 10in).

Acrylic is a quick-drying medium which allows a versatile approach. The thickness of the paint is one of the factors that determines drying speed. Areas that are built up quickly with the knife take longer and can be worked into while the paint is still wet.

COLOUR ON COLOUR

In the painting, colour is generally applied over another colour which has been allowed to dry. However, in places one colour is applied over another colour which is still wet. In these areas care must be taken not to overwork the paint and muddy the colours.

For example, the poppy heads are simply smudges of red applied with the tip of a knife over the corn colour while it is still wet. These smudges create an overall impression of the flowers rather than a detailed rendering. Any attempt to add detail or make the individual poppies look more realistic would mix the wet colours and spoil the effect.

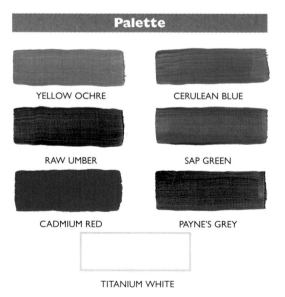

Palette

YELLOW OCHRE CERULEAN BLUE

RAW UMBER SAP GREEN

CADMIUM RED PAYNE'S GREY

TITANIUM WHITE

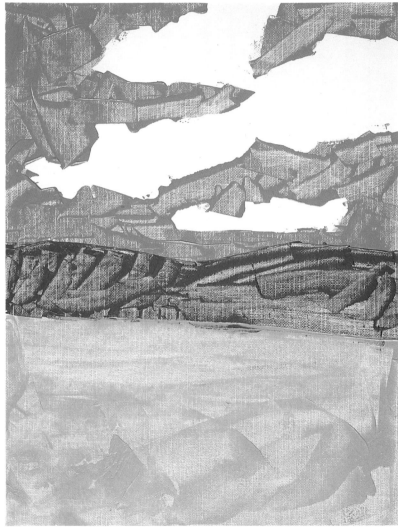

STEP 1
Loosely block in the main areas with the knife. The sky is a mixture of titanium white and cerulean blue, the clouds the unpainted white of canvas. The hills are sap green with a touch of raw umber; the cornfield is yellow ochre with white.

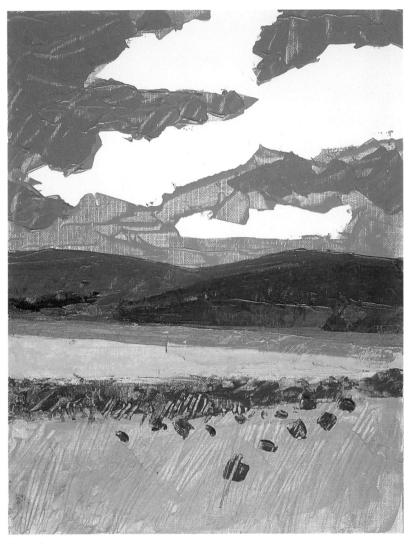

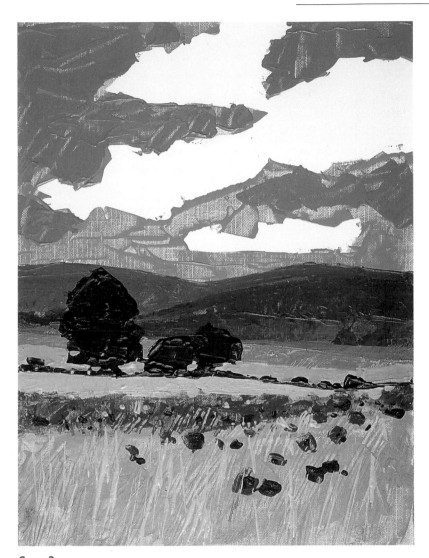

When painting expanses of a single colour, apply the knife strokes randomly in different directions. If you do this in the very first stages the painting gets off to a lively start and sets a mood of spontaneity for the rest of the work.

STEP 2

Darken shadow areas – Payne's grey, raw umber and sap green on the hill; darker blue for the sky. Lighten foreground corn in yellow ochre and white and then add the poppies in cadmium red. Scratch vertical strokes to indicate foreground corn.

STEP 3

Paint the trees and hedge thickly in a mixture of sap green, raw umber and Payne's grey. Add a few darker poppies in cadmium red mixed with Payne's grey. Finally, use the edge of the knife to paint paler heads of corn.

Washes

Acrylic washes are usually laid for one of two reasons. The first is that you want your acrylic painting to look like a watercolour, in which case all the colours are applied thinly in the form of diluted washes.

Alternatively, thin washes make an excellent starting point for any acrylic painting, even one which ends up being very thickly painted. Use the quick-drying washes in the early stages to establish the main picture areas without building up unnecessary thicknesses in the early stages.

When you are happy with the composition and the general colour scheme has been worked out, allow the washes to dry, then continue to build up the painting.

Aims

- To achieve watercolour effects by diluting acrylics with water or mediums
- To mix colours by glazing a diluted colour over another colour
- To use the watercolour technique of working from light to dark – starting with the whites and light tones and gradually building up with increasingly dark tones

LANDSCAPE WITH WASHES

For this simplified landscape, which measures 13x10cm (5x4in), use a 19mm (¾in) soft flat brush. For larger expanses of colour, you will need a bigger brush. Use Cryla paper or sturdy cartridge paper pinned to a board propped at a slight angle. Before painting, dampen with a sponge.

Use a jar or other container for mixing the two main washes – the cerulean blue sky and sap green field (the paint is too thin to be mixed on a normal palette). Start by mixing the colour you want in the normal way, then dilute the paint by adding water a little at a time until you have the strength of colour required.

For quantities of colour as small as those you are using here, use a brush; for larger amounts, use a pipette or teaspoon.

With each addition of water, test the wash colour for strength on a piece of scrap paper. Colours usually get paler as they dry, so make allowances for this.

Because washes are transparent and because they are insoluble once dry, it is important to get things right first time.

STEP I

Load the brush with colour and paint a single broad stroke across the top of the paper. (For larger areas of wash, use a larger brush.) Reload the brush and paint a second stroke directly underneath this, slightly overlapping the first stripe. Pick up the rivulet of colour which will have collected there from the first stroke. Continue in this way until the sky is complete.

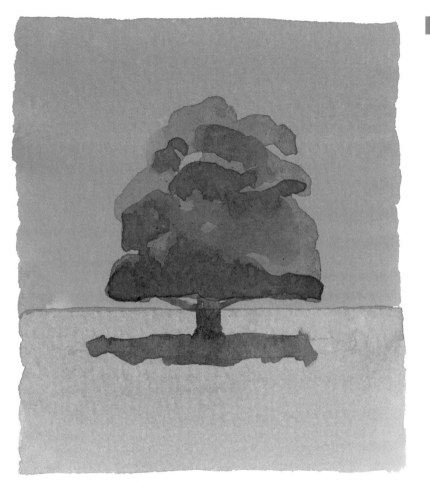

Tip

Tastes vary when it comes to wash brushes. The demonstration here was painted with a flat brush. However, some artists feel a large round is better because it holds more colour. Others choose a soft 'mop' brush, especially useful for large areas.

STEP 2

Mix a sap green wash. When the first colour is completely dry, load the clean brush with colour and lay the first green stripe to slightly overlap the edge of the blue. Continue as before until you reach the bottom of the paper. Allow to dry. For a softer horizon line, apply the green before the sky blue is quite dry.

STEP 3

The tree is painted using a 6mm (¼in) flat brush. Start with a thin wash of viridian and sap green for the foliage. Add darker greens while still wet, allowing the dark tones to bleed slightly into the paler colour. Paint the trunk in diluted raw umber and the shadow in a thin mixture of sap green and raw umber.

OVERLAID COLOUR

Overlaid washes of acrylic are used to create colour mixtures which have a translucent filmlike quality, rather like sheets of coloured glass. The technique, which is known as glazing, can change the underlying colour without obliterating it.

The strength of the glaze depends partly on the staining power of the top colour, and partly on how much the glazing colour has been diluted. Some pigments produce a stronger tint than others. For example, phthalo blue and alizarin crimson are strong colours which will overpower the underneath colour. Raw umber, which has a low tinting power, will modify the underlying colour without dominating it.

The overlaid colours here show the effects when one colour is laid over one other colour. However, a glaze can be built up using several layers of colour to create a shimmering and varied multicoloured effect.

Glazes can also be used over thick paint and highly textured surfaces.

GLAZING MEDIUMS
Water alone produces a matt finish when mixed with acrylic colour. However, diluted with a gloss medium, the paint dries with a glossy or semi-glossy finish depending on the absorbency of the surface.

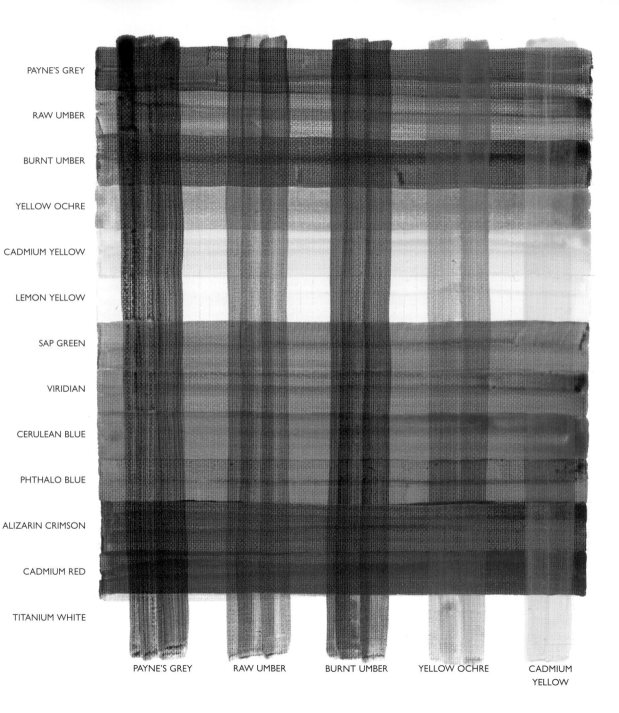

PAYNE'S GREY
RAW UMBER
BURNT UMBER
YELLOW OCHRE
CADMIUM YELLOW
LEMON YELLOW
SAP GREEN
VIRIDIAN
CERULEAN BLUE
PHTHALO BLUE
ALIZARIN CRIMSON
CADMIUM RED
TITANIUM WHITE

PAYNE'S GREY RAW UMBER BURNT UMBER YELLOW OCHRE CADMIUM YELLOW

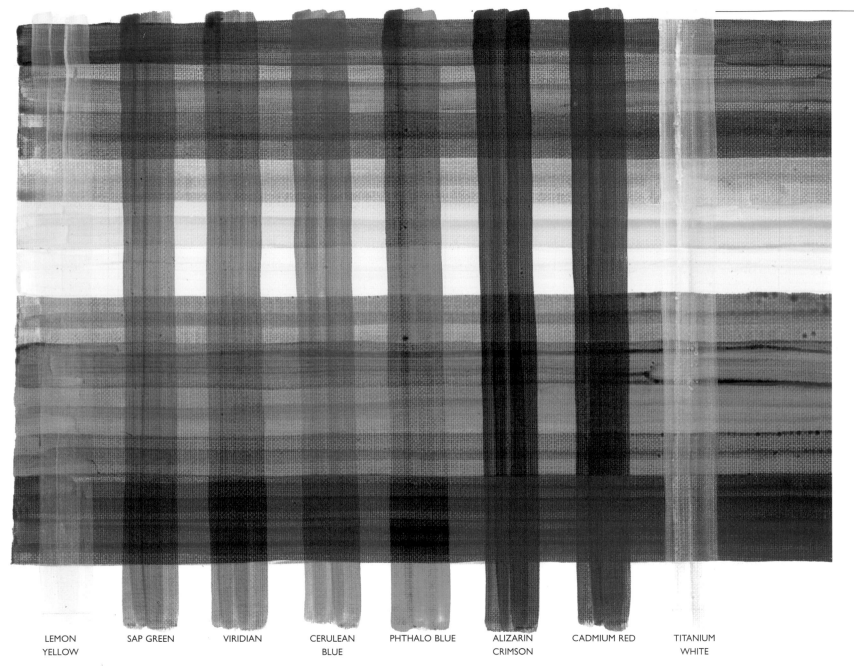

Glazed colours have a depth and luminosity which is not achievable by simply mixing the colours on the palette. The illustration on these pages demonstrates the effects that can be achieved by overlaying pairs of colour from the basic palette.

LEMON
YELLOW

SAP GREEN

VIRIDIAN

CERULEAN
BLUE

PHTHALO BLUE

ALIZARIN
CRIMSON

CADMIUM RED

TITANIUM
WHITE

LAKELAND FARMHOUSE

To use acrylics like watercolour the paint must be very diluted. For small areas, colour can usually be mixed on a flat palette in the normal way. But for larger areas, it is often easier to mix the colour in a deep palette, saucer or jar. This way you can mix a quantity of paint to the same consistency – enough to lay a large area of even, flat colour (see page 56).

Because diluted colours are transparent you cannot cover a colour with a lighter colour by painting over it. This means you must work from light to dark – starting with the palest areas then gradually building up to the darkest tones.

Whites can be made by leaving specific areas of white paper or primed canvas unpainted. However, if you forget to do this, all is not lost. You can cheat by using white paint in the final stages. So squeeze out a little white on the palette, just in case.

LIGHT TONES FIRST

The first stage of this lakeland landscape is achieved by laying a series of light, washy colours representing the palest tones of the subject. The darker colours are then painted on top.

For crisp shapes and hard edges, such as the building, wait until the first washes are dry before painting on top. An alternative approach is to apply colour on to paint which is wet or partially dry. This technique, sometimes referred to as 'wet-into-wet', produces blurred brushstrokes and soft edges. Here, the wet-into-wet approach is used on the background hills and the water. Finally, brighten up the farmhouse with a little white.

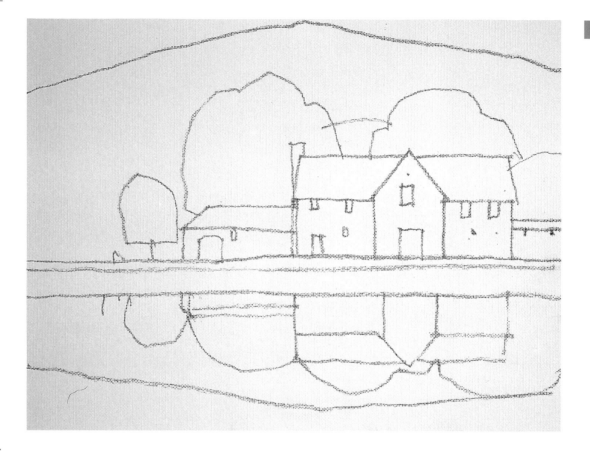

PALETTE

PAYNE'S GREY

CERULEAN BLUE

SAP GREEN

YELLOW OCHRE

RAW UMBER

TITANIUM WHITE

For this painting you will need:
Palette colours
Brushes: 12mm (½in), 6mm (¼in)
and 3mm (⅛in) flats
Sheet of Cryla 25x33cm (10x13in)
Carbon pencil for drawing

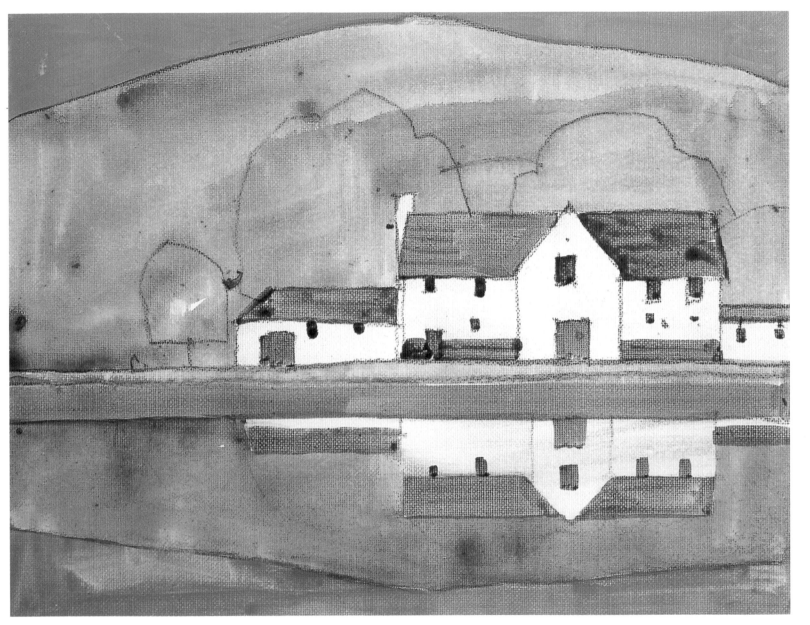

STEP 1
Using the 12mm (½in) flat brush, paint the sky in diluted cerulean blue. Dampen the water area, then apply the same cerulean blue mixture in loose strokes to create a runny wet-into-wet effect. When the blue is dry, paint the hill with a sap green and raw umber. Add a little more sap green to this mixture, then paint the reflection of the hill. Change to the 6mm (¼in) brush and paint the roof in diluted Payne's grey. Paint the road and rendering on the house in diluted yellow ochre and raw umber respectively.

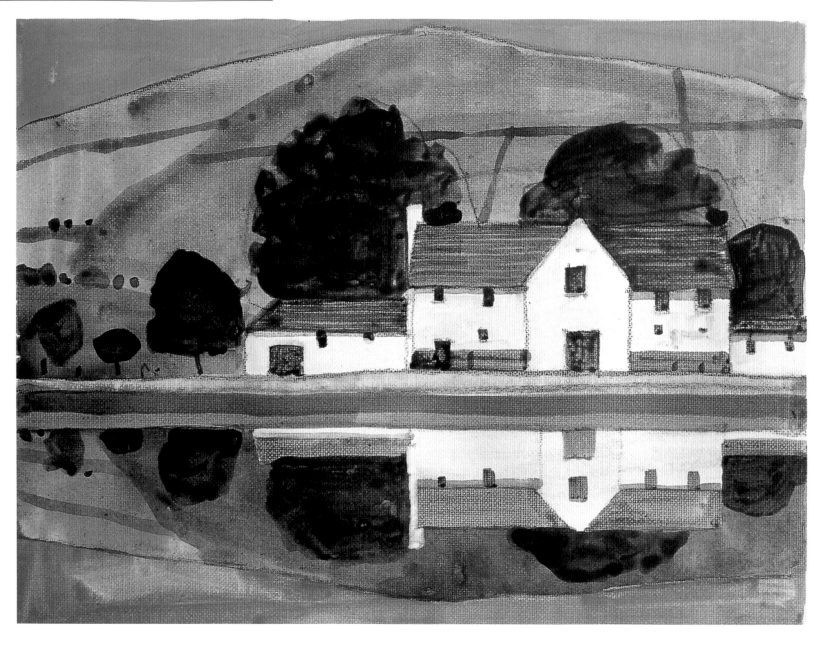

STEP 2

Allow the first stage to dry completely. Mix a dark green wash of sap green, raw umber, yellow ochre and Payne's grey. Use the 6mm (¼in) brush to apply this to the trees and hedges and their reflections. Paint horizontal lines of Payne's grey across the roof to suggest the tiles.

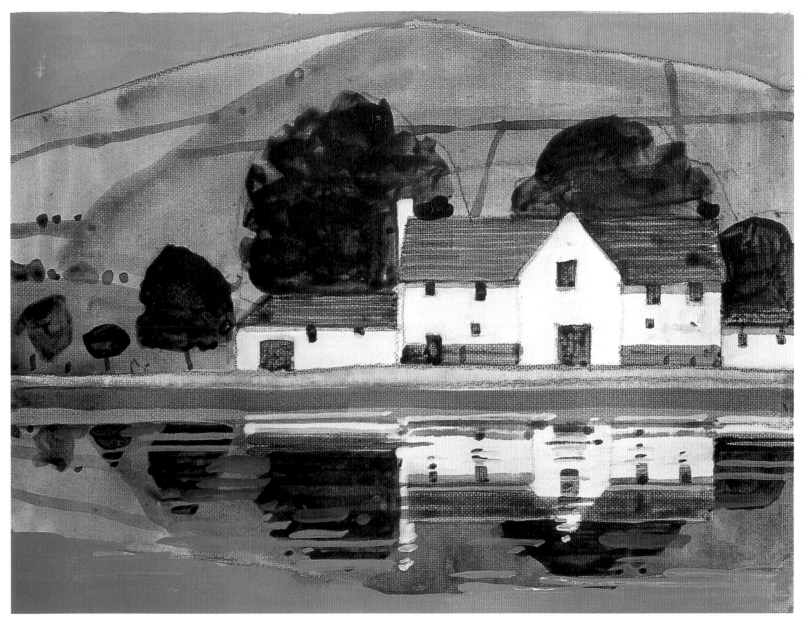

STEP 3
Use the 3mm (⅛in) brush to paint horizontal lines for the ripples in the water. For the light green lines, add a little white to the tree mixture. Strengthen the sky with a slightly thicker wash of cerulean blue, painting horizontal lines of this into the reflected tree to create more ripples.

Creating Form

A shape is flat; a form is solid and three-dimensional. Sadly, too many beginners concentrate on the shapes in their paintings and neglect the all-important forms. However, in order to make any subject look convincing and realistic it is necessary to create an illusion of three-dimensional space and form on the flat, two-dimensional painting surface.

All this sounds rather technical, but in fact it is achieved quite easily by putting in a few shadows and highlights. Accurately placed, these will transform any flat shape into a credible object.

Aims

- To create the illusion of three-dimensional space and form on a flat surface
- To paint objects with flat and rounded surfaces
- To describe form by using just three tones of the same colour – light, medium and dark

LIGHT AND SHADE

The use of light and shade is demonstrated very easily by taking as your subject a simple box or cube and placing it on a plain surface. Look carefully at the subject and decide on the source of light – the direction from which the light is coming. This may be a window, the sun, a candle, or any other form of natural or artificial light.

The palest side of the cube is the one nearest the source of light; the side facing away from the light is the darkest. This may seem obvious, but it applies to all subjects and is one of the most important and helpful principles of painting.

Now, apply the same principle to a ball or any other round object. Light falling on a spherical or curved surface also creates light and dark areas. But on a rounded surface there is no sharply defined division between the highlight and shaded area as there is on a cube. Instead, colour changes gradually from the dark shadowy areas, through the medium tones to the palest spot where the light falls.

Blue building blocks painted in three tones – pale blue where the light falls, darker blues for the shaded sides.

MIXING LIGHTS AND DARKS

However complex your subject, it is important to first identify the source of light. Next, pick out the light, medium and dark areas created by the light source.

For example, the blue cube is seen in three tones of blue – light, medium and dark. If you find it difficult to see the tones, try looking at the subject through half-closed eyes. This will eliminate some of the colour and detail, making it easier to pick out the light and dark areas.

A pale shade of any colour can be mixed by adding white. Darker tones can be achieved by adding black. However, as black can have a muddying effect on a colour it is worth trying Payne's grey, raw umber or a mixture of darker colours to produce livelier alternatives.

Before starting to paint, look carefully at the reflections, highlights or shadows in any subject. Inevitably they contain more colour than might be expected. For instance, shadows are rarely grey, and highlights rarely pure white. Both tend to contain traces of surrounding colours, such as the colour of a background wall or tablecloth.

On a ball the shadow follows the rounded surface and has a softened edge. The darkest tone of the shadow is that which is furthest from the light.

TOYS

It is not always easy to see shadows, even under a very strong directional light. This is especially true if the subject is at all complicated – one which is made up of intricate shapes and forms, or containing a large number of colours and tones.

When faced with something as seemingly complex as this, the best approach is to try and simplify what you see.

For example, at first glance the shadows on the toy engine and carriages in this painting look difficult – far more complicated than the blocks next to them. In fact they are not, and each toy is made up of a number of simple, geometric forms. These have straight or rounded symmetrical surfaces, exactly like the blocks and balls on the previous page.

The colours on all the toys are simplified into three main tones. Hence, the toys are each painted in a main colour of bright red, green, blue or yellow. For the highlight on each toy, this main colour is then mixed with a little white. Darker, shaded areas are painted in a darker mixture of the main colour.

A VERSATILE FORMULA

Geometric toys painted in the primary colours are obviously an easy subject, and have been chosen specifically for this project. But once you have tried the 'three tone' approach you will discover how versatile it is, and also how it can be applied to almost any subject, however complicated it may be.

CADMIUM RED

ALIZARIN CRIMSON

PHTHALO BLUE

PAYNE'S GREY

VIRIDIAN

SAP GREEN

YELLOW OCHRE

CADMIUM YELLOW

TITANIUM WHITE

Palette

For this painting you will need:
Palette colours
Brushes: 12mm (½in), 6mm (¼in) and 3mm (⅛in) flats
Sheet of Cryla paper 25x25cm (10x10in)
Carbon pencil for drawing

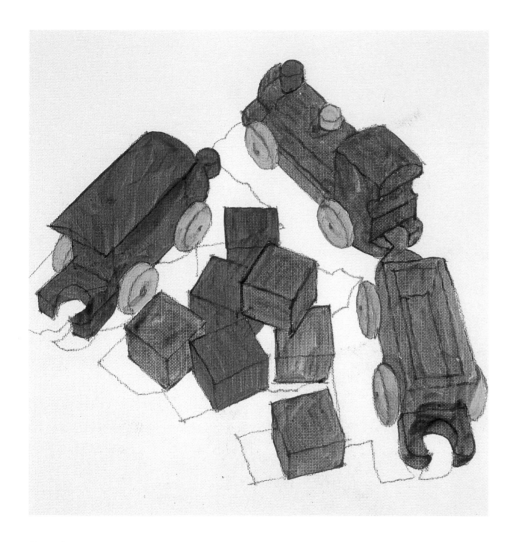

STEP 1

With the 6mm (¼in) brush, loosely fill in the toys with thin washes of diluted paint. Colours are cadmium red, phthalo blue, cadmium yellow and a mixture of sap green and viridian. Do not worry about visible brushstrokes – these will be covered by thicker colour eventually.

STEP 2

Change to the 12mm (½in) brush and paint the background with a thin mixture of white, yellow ochre and Payne's grey. Again, paint loosely and do not worry about uneven brushmarks.

STEP 3

Change to the 3mm (⅛in) brush and paint the shaded areas on each toy using a thicker mixture of the initial colours – cadmium red for the engine, cadmium yellow for the wheels, and so on. Paint the thrown shadows in a mixture of Payne's grey, phthalo blue and alizarin crimson.

STEP 4

Using the same brush, paint the palest tones on the toys using a little of the main colour with white. Go over the main colours using a thicker mixture of the original colours.

STEP 5

Strengthen the dark tones, using the main colour mixed with Payne's grey and a little alizarin crimson. Take the colour up to the edge of the first colour, leaving a cleanly painted edge.

STEP 6

Use the 12mm (½in) brush to strengthen the background in a thicker mixture of the original colour – white, Payne's grey and yellow ochre. Change to the 6mm (¼in) brush and paint the highlights in white with an added touch of the main colour of the toy.

LESSON SIX

Still Life

Composition is a matter of personal choice, and it may be conventional or highly eccentric. But it is always important – a fundamental part of a painting which should be given careful consideration.

For the newcomer to acrylic painting, a still-life subject provides the best possible starting point. It forces the most basic decisions. Where should the subject be placed on the canvas? How should the objects be arranged within the subject? How much space should you leave around the subject?

The arrangements can be very simple – a single object constitutes a still life – or as complicated as you like. Best of all, you can arrange the subject to suit yourself and leave it there for as long as it takes to paint it.

Arranging objects is a great way of learning about composition. The painting starts with the choosing and setting up of the subject, not when the first mark is made on the canvas.

SETTING UP

First, you will need some everyday objects – the kitchen or the potting shed are good places to start. Choose a few different shapes. As a rule, the more variety you have, the more scope there is for putting together an interesting composition. A selection of contrasting light and dark objects generally provides a more attractive arrangement than a collection of items which are all the same tone.

Now for the creative part. Try out every possible arrangement of the objects to hand until you arrive at something you would really like to paint. If you find that getting started is a problem, try tipping all the pieces on to a table top and take it from there.

Inevitably, any subject is made up of many different shapes, including the shape of the table top and the shape of the background. These can be changed and controlled by moving the objects around, positioning one in front of another, and changing the distance between each one. It is interesting to notice how the slightest change in the arrangement changes the relationship between the different objects.

Try painting a subject as an abstract arrangement using arbitrary colours. This allows you to isolate shape and composition from familiar objects.

70

THINKING OF SHAPES

The trick is this: think of each object as a shape – an abstract element rather than a cup, a flower pot, or whatever it happens to be. If the arrangement works well as a series of abstract shapes, then the chances are that your still-life painting of the same arrangement will work equally well.

The abstract painting opposite was done prior to the still-life painting. Although the subject is barely recognisable, it is painted from exactly the same arrangement of garden tools. But in the abstract version each object and the background and foreground areas are considered and painted as flat shapes in colours unrelated to the actual colour.

Without the distraction of looking at familiar, recognisable objects it is possible to see clearly the layout of the composition and how the shapes work in relation to each other.

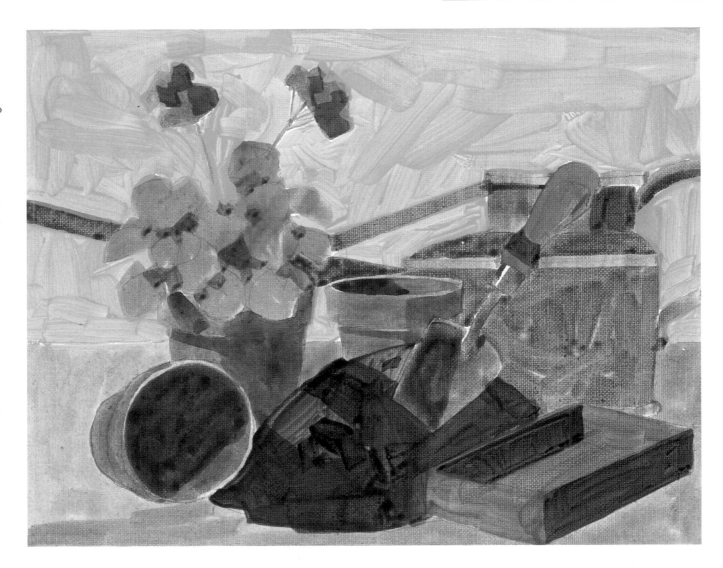

The finished still life of recognisable gardening tools foraged from the potting shed reflects the thought and formal planning which went into its composition.

SHAPES AND SPACES

It sounds like nonsense to say that the empty spaces in a painting are as important as the shapes. Nevertheless, this is the case simply because in a painting the empty spaces *are* shapes. And these shapes, sometimes called negative shapes, are as important to the composition as the subject itself. They also usually account for more of the picture area.

NEGATIVE SHAPES

The negative shapes include the background and foreground shapes, the shapes of the spaces between objects, the shape of the space within a cup handle, and so on. As can be seen from all the illustrations here, the space defined by a cup handle is as precise and clear as the handle itself.

The shape and proportion of your canvas will dictate the shape of the space left around the background. If, as is usual, your canvas is square or rectangular, the shapes of the background and foreground areas will generally have one or two straight edges – rather like the edge pieces of a jigsaw puzzle.

The shape of these surrounding spaces can often determine the way in which the viewer perceives a picture. A tall subject, such as a tree or a figure, will generally look taller on a vertical canvas. On a horizontal canvas, with lots of space at the sides but less at the top and bottom, the subject can look short and cramped.

A NEW APPROACH

If all this seems rather theoretical, the exercise actually has a very practical purpose. Beginners often make the mistake of making the subject of the painting much too small, leaving a mass of boring, empty space around it.

The best way of avoiding this is to draw the spaces first whenever you start a painting. This way, the subject emerges from the surrounding negative shapes of the foreground and background. Working in this order ensures that the surrounding areas are properly considered, and that they play as important a role in the composition as the subject.

Plants and flowers are generally easier to draw if you start with the spaces between the leaves and stems; domestic utensils – particularly those with spouts, handles and knobs – create intrinsically interesting spaces when grouped together.

However, it is not only when painting still life that the 'spaces first' approach is useful. Whatever the subject, attention to the negative shapes will help produce an integrated, more interesting composition.

In a simple still-life study of two mugs, the shapes formed by the table top and background wall are as interesting and important as the mugs themselves.

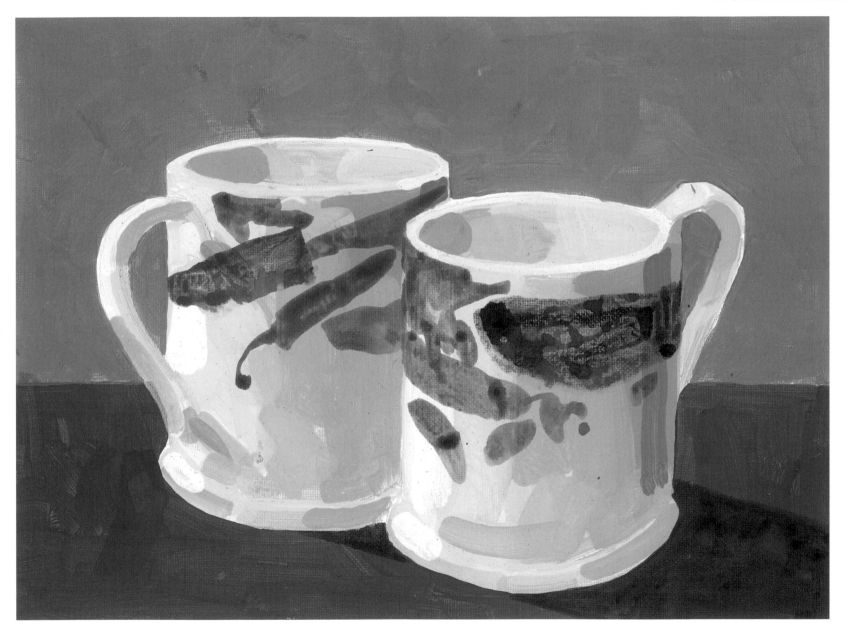

In the painting, the mugs with their colourful eye-catching patterns are the focal point. However, the surrounding shapes support the central subject and are an integral part of the composition.

BUTTERCUPS

There is no such thing as a dull subject, only a dull picture. On its own, this mug of buttercups could easily have made a very boring painting. But the clever use of negative background shapes and a bold tablecloth creates a striking composition which transforms a bunch of flowers into a lively and attractive picture.

The picture is divided horizontally into two almost equal halves by the edge of the table. But the composition is prevented from being totally symmetrical by placing the mug of flowers to one side of the picture. The position and shape of the flowers and mug determine the shape of the strong purple background, which becomes an important element in the overall composition.

In addition, a bold blue and white checked cloth is used to contrast with the plain purple of the background. Dark blue lines, and the white shapes created by these lines, are an important feature of the overall arrangement. So too is the strong directional light which throws a long dark shadow, creating further shapes and spaces.

STRAIGHT LINES

Shapes and spaces are crisply painted using hard edges and straight lines which lend a

distinctive graphic quality to the painting. For a really sharp edge, you can use masking tape – the straight edge of the tape for a straight line, or torn edges for crisp, irregular lines.

Practise a little, rather than trying out the tape for the first time in this project painting. The consistency of the paint must not be too runny otherwise the colour seeps under the tape and spoils the effect. Also, it is a good idea to wait until the paint is dry before removing the tape because this avoids possible smudging.

In this painting the masking tape is used to paint the shapes of the flower shadows.

For this painting you will need:
Palette colours
Brushes: 6mm (¼in) and 3mm (⅛in) flats
Sheet of Cryla paper 18x20cm (7x8in)
Masking tape
Carbon pencil for drawing

USING MASKING TAPE

Press tape firmly down on the paper. Apply fairly thick colour, painting over the edges of the tape. When the paint is dry, remove the tape to reveal a crisp straight edge.

TITANIUM WHITE

CADMIUM YELLOW

CADMIUM RED

ALIZARIN CRIMSON

PAYNE'S GREY

PHTHALO BLUE

VIRIDIAN

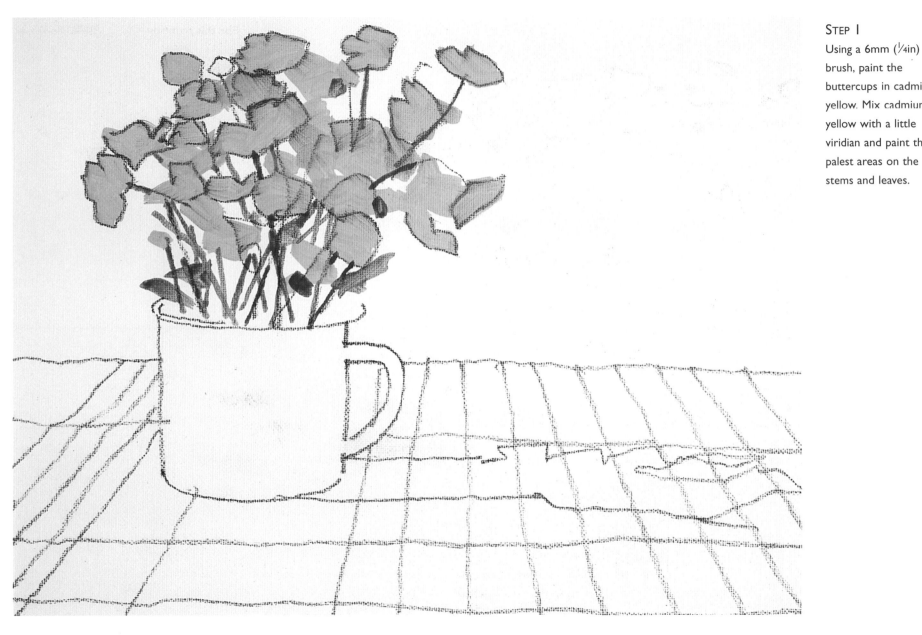

Using a 6mm (¼in) flat brush, paint the buttercups in cadmium yellow. Mix cadmium yellow with a little viridian and paint the palest areas on the stems and leaves.

STEP 2

Work into the flowers by painting the dark areas with cadmium yellow mixed with a little cadmium red and Payne's grey. Paint the pale areas with cadmium yellow mixed with white. Mix viridian with a little Payne's grey and cadmium red, and add the dark parts of the stems and leaves.

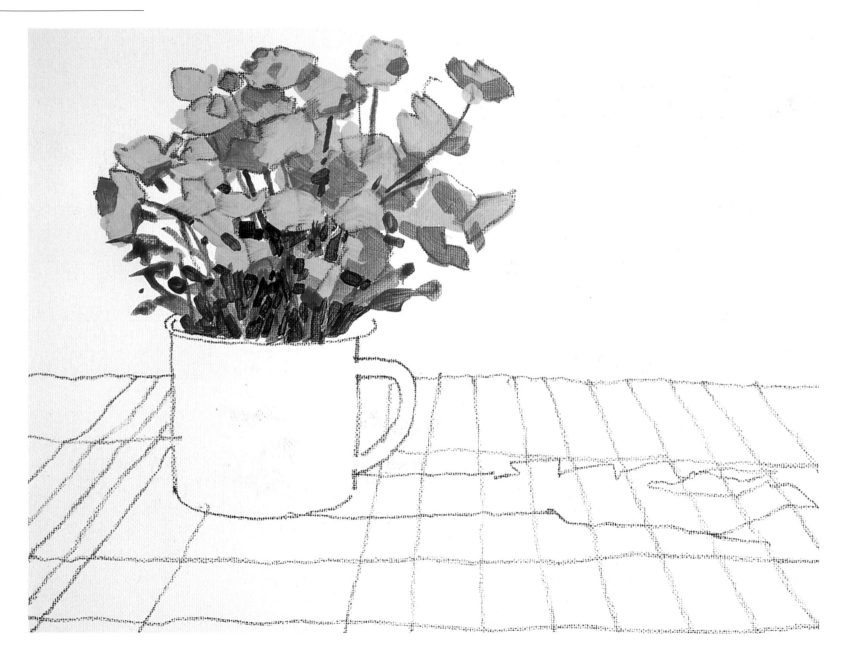

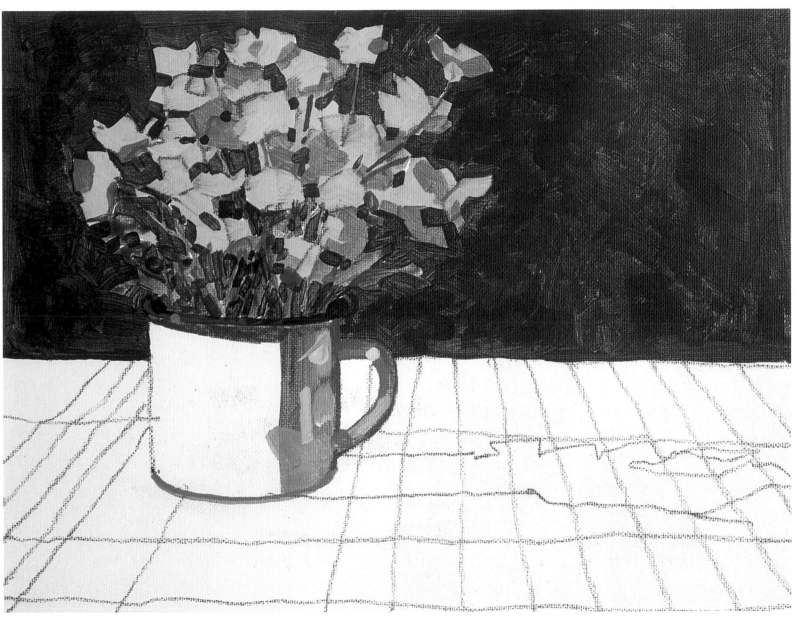

The purple background is mixed from Payne's grey, cadmium red and a little white. Apply this boldly with loose brushstrokes to get a patchy, textural finish. Change to the 3mm (⅛in) brush and paint the rim of the mug in phthalo blue and the shadows in Payne's grey mixed with a little white.

STEP 4

Using the 6mm (¼in)
brush, paint the stripes
on the cloth in Payne's
grey mixed with a little
cadmium red and
white. Brighten the
white stripes and mug
by applying white paint.

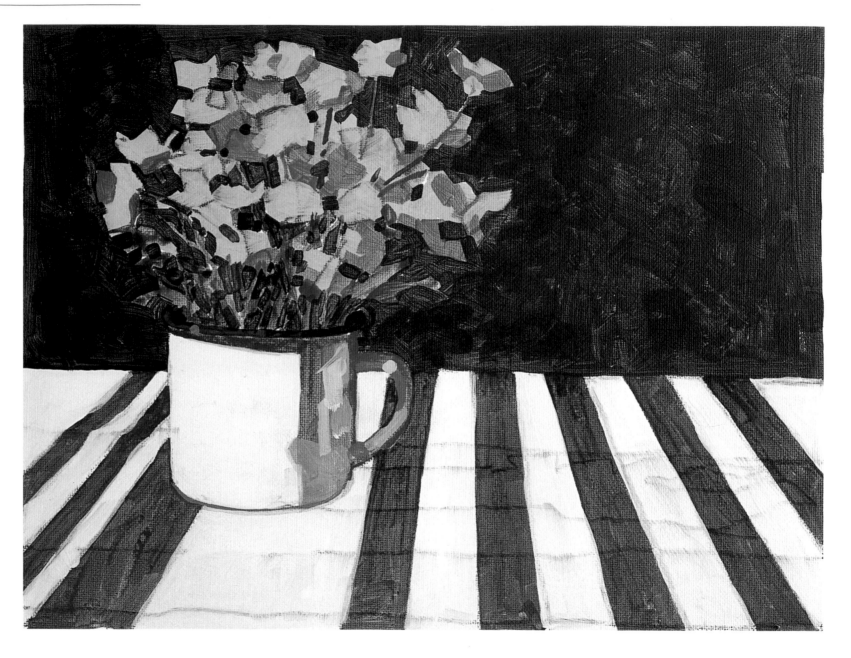

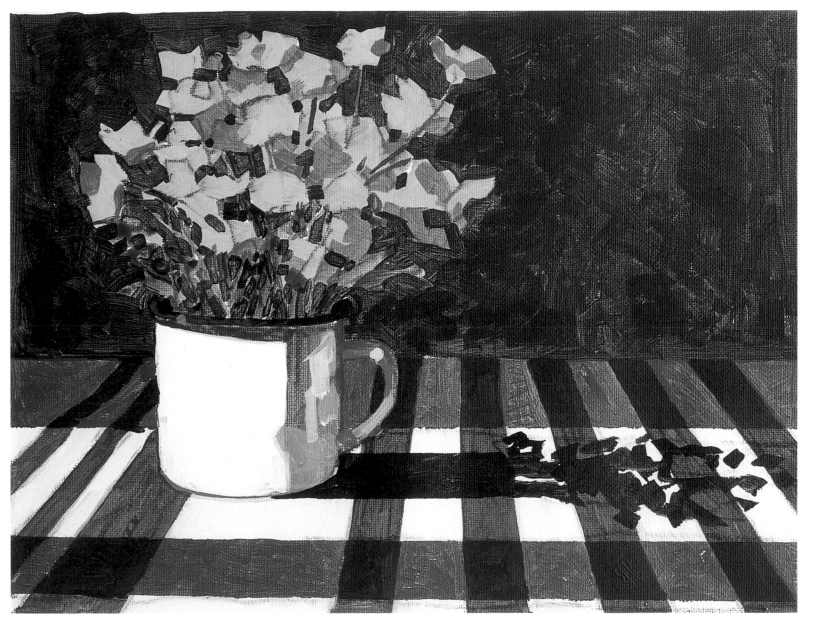

Paint the horizontal blue stripes and allow to dry, then paint the shadow of the flowers and mug. Tear the tape in small pieces and arrange around the edge of the shadow shape. Paint the taped off area in a mixture of Payne's grey and phthalo blue with a little added cadmium red and white. Finally, allow to dry and remove the tape.

Effects with Paint

Everything we see has its own texture or surface pattern. This is especially true of natural forms such as plants, shells, foliage, rocks and wood.

The more you look, the more intricate and complex these surface patterns and textures will appear. But is it really possible to capture the rippling surface of a beech leaf, or to depict the tiny flowers on a head of lilac with paint?

The answer, of course, is yes – but it will take a little imagination and invention, and

Aims

- To exploit the medium's particular versatility
- To master ways of achieving broken colour
- To learn ways to reproduce the surfaces we see around us
- To develop a repertoire of short-cuts and techniques which will quickly capture these surfaces
- To encourage exploring new ways of applying paint
- To develop a repertoire in the use of tools and materials, including the unorthodox

you will also have to take a few short-cuts.

Fortunately, when painting with acrylics you are not confined to brush and knife alone. Nor are you restricted to simply painting areas of a single mixed colour. The paint can be used in a purely creative way to get as much textural variety as you want into the painting.

TAKE A FLOWER

Every plant, leaf and flower has its own special characteristic – a texture, pattern or colour variation without which the painted flower has no personality and cannot be identified. For instance, the lily on the opposite page did not look like a lily at all until dark spots of paint were spattered across the orange petals with an old toothbrush.

To recreate other effects on the rest of the flowers, candle wax, cardboard and a piece of bathroom sponge were used. Each flower demonstrates a way in which acrylic paint can be applied to capture a particular surface effect, or to break up an area of tone or colour. Try these, then use your imagination to create your own effects.

Petals and stems are applied by dragging paint with an appropriately sized piece of card.

Star-shaped flowers are depicted by applying paint with the edge of a piece of card.

Tip

Get into the habit of collecting the items, even the eccentric ones, which can be used to apply paint. Thus a piece of candle, or an old toothbrush, will be ready to hand along with your regular painting kit.

Painting over candle wax scribbles creates patches of dappled light on leaves.

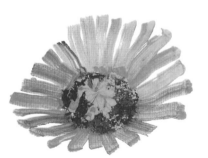

The centre of the flower is stippled through a hole cut in a sheet of paper or card.

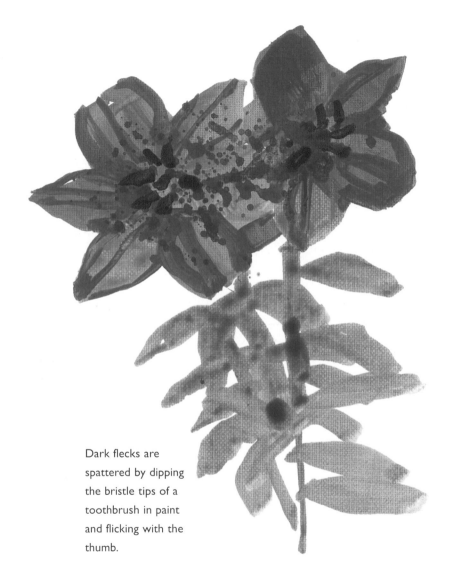

Dark flecks are spattered by dipping the bristle tips of a toothbrush in paint and flicking with the thumb.

81

BROKEN COLOUR

Any means of applying paint in order to change and break up an area of colour without completely covering it is referred to as 'broken colour'.

Broken colour is particularly useful when you want to make changes of tone or colour in one area of painting without changing the balance and overall composition of the whole picture. It is also useful for imitating specific natural textures such as the seashells painted here.

DRYBRUSH AND SCUMBLING

Drybrush and scumbling are perhaps two of the most popular techniques used to apply one broken colour over another flat undercolour.

For drybrush painting, squeeze as much moisture from the brush bristles as possible. Dip the bristles in a fairly stiff mixture of paint and drag the brush lightly over the dry undercolour.

A scumbled surface is where the visible brushstrokes allow underlying colours to show through. Brushstrokes may be stippled or long, random or ordered. A

Scumbled white with gloss medium over pink and brown underpainting.

Burnt umber applied with a synthetic sponge over lighter underpainting.

scumble may be painted over flat colour or an impastoed, textural surface.

The dramatic textures created by spattering and sponging which enhanced the flowers on the previous page, can also be use to break up areas of flat colour.

Light grey applied as
thumbprints over
Payne's grey
underpainting.

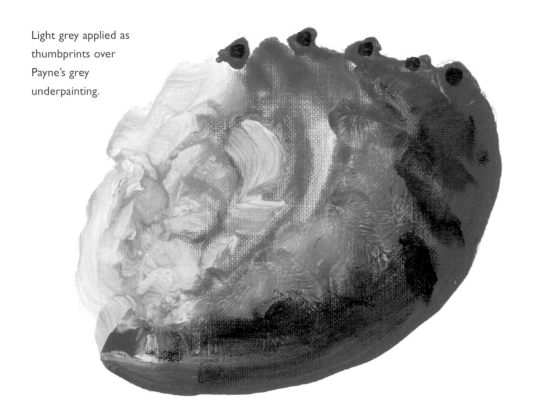

Burnt umber mixed
with white and
spattered over darker
underpainting.

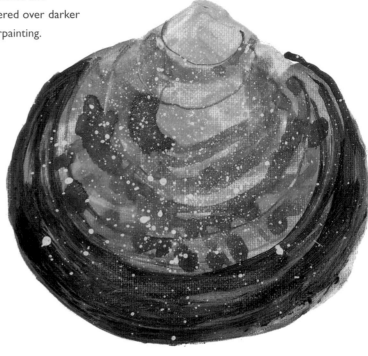

Burnt umber shadows
drybrushed over
lighter underpainting.

A selection of broken
colour techniques
including drybrush,
scumbling, spattering
and sponging can be
used to add texture
and modify areas of
tone or colour.

PANAMA HAT

Try putting a few textures and surface patterns to practical use in this project. The colours in this picture are subdued and the composition is simple. Textures and patterns are therefore an important focal point in the painting.

All the textures are quick and easy to do. There is no point getting involved in fussy detail because it will be lost in the finished painting. The bolder you are, the more effective your efforts will be.

PRINTING AND SCRATCHING

The painting starts with printed leaf shapes. These get the painting off to a lively start and are much quicker than painting with a brush. A piece of stiff card cut to the shape of a leaf with a drawing pin as a handle was used for the printing, but there are a number of possible alternatives. For instance, a piece of synthetic sponge or polystyrene cut to a suitable shape would do the job just as well.

Canvas weave on the chair is achieved by pressing a piece of textured kitchen roll on the wet paint. Again, similar results can be obtained with other materials and it is worth experimenting with real canvas, hessian and other fabrics.

To break up the large expanse of floor,

paint is dabbed on with a scrunched up piece of natural sponge. A convincing wood grain on the folding chair is achieved by scratching into the wet paint with a scalpel. And a final touch is the straw texture of the Panama hat; this is thick paint stroked on in parallel lines using a dry brush.

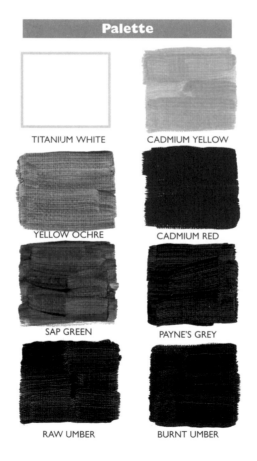

Palette

TITANIUM WHITE	CADMIUM YELLOW
YELLOW OCHRE	CADMIUM RED
SAP GREEN	PAYNE'S GREY
RAW UMBER	BURNT UMBER

For this project you will need:

Palette colours

Brushes: 6mm (¼in) and 3mm (⅛in) synthetic flats

Sheet of Cryla paper 38 x 33cm (15 x 13in)

Carbon pencil for drawing

Scalpel, natural sponge, cardboard, drawing pin and kitchen roll for texture making

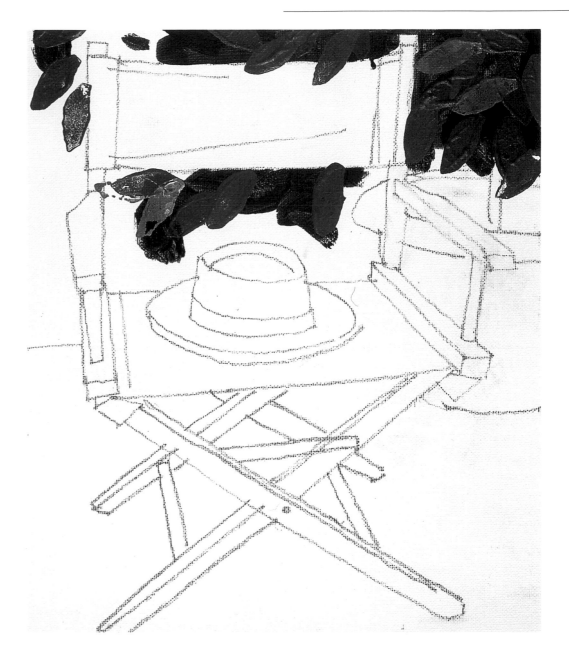

Practise a little before printing the leaves. If the paint is too thin it will run. Thick paint creates a textured surface with occasional gaps of broken colour, as in the palest leaves *above*. If you do not want this effect, remove excess paint by printing on a piece of scrap paper until you have the effect you want.

STEP 1

From a sheet of card cut a leaf shape about 25mm (1in) long and use a drawing pin as a knob to hold the shape. Mix a thick leaf green from sap green, cadmium yellow, yellow ochre and Payne's grey, and print leaf shapes over the tree area. Add a little white in stages and print lighter green shapes on top.

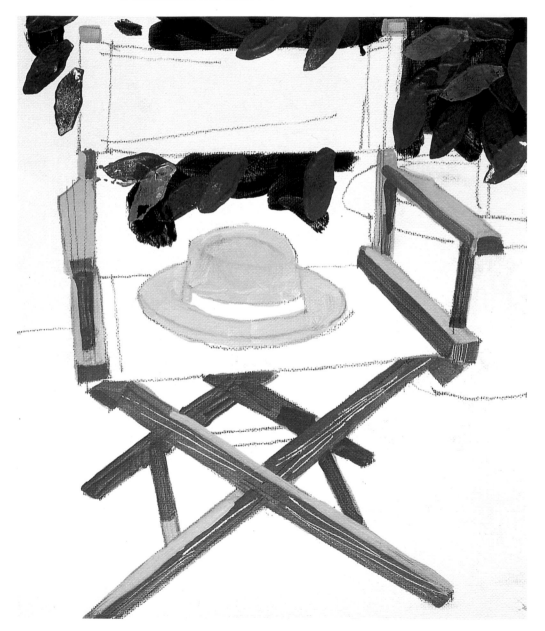

Using a 3mm (⅛in) brush, paint the light wooden areas and the Panama hat with a mixture of yellow ochre, raw umber and white. Darken this with Payne's grey and more raw umber for the dark wood colour. While this is still wet, use a scalpel to scratch a few lines of wood grain.

Tip

The wood grain in the painting is made by scratching into the wet brown paint to reveal the white support underneath (*above left*). It is worth experimenting with this versatile technique, for future use. For example, you might try reversing the colours to get a dark grain by painting the brown first. When this is dry, paint a lighter colour on top and scratch the grain pattern before this dries (*above right*).

Tip

In the painting the back of the chair is dabbed with textured kitchen roll to indicate the texture of the canvas. Similar effects can be obtained using fabrics. For example, the reverse side of a piece of velvet was used to create the above textures. Coarser effects can be reproduced by using open-weave fabrics such as canvas or hessian.

STEP 3
Using a 6mm (¼in) brush, paint the dark canvas colour with a mixture of Payne's grey, burnt umber and a little white. Add more white for the lighter canvas areas. While this is still wet, take a sheet of textured kitchen roll and press into the wet paint.

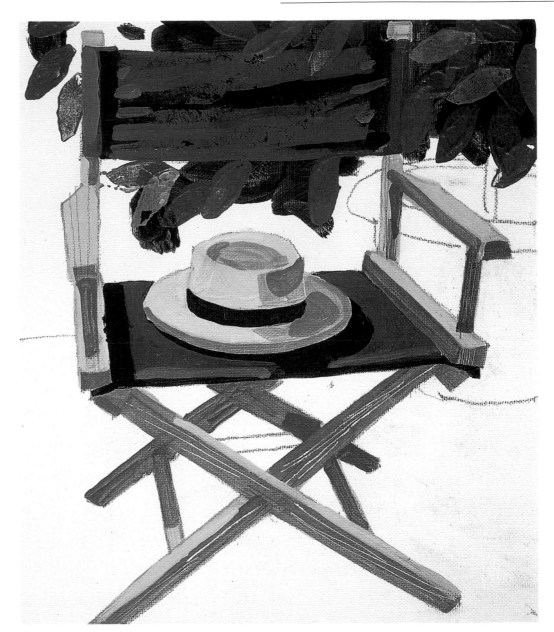

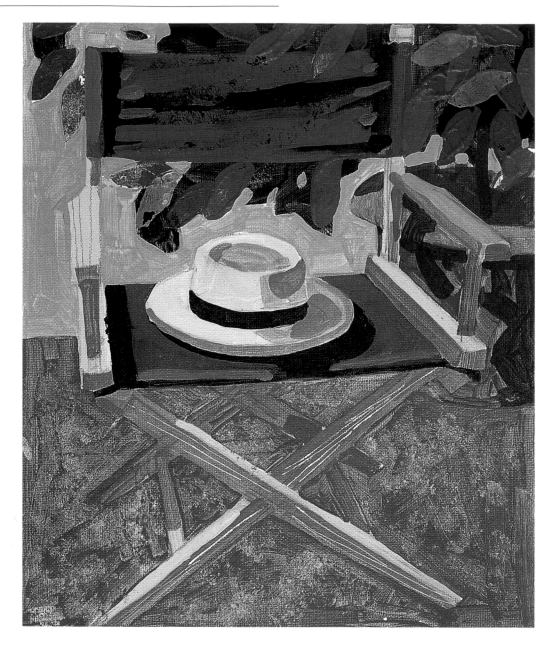

STEP 4

The wall behind the chair is painted in a mixture of Payne's grey and white. For the floor, use a mixture of raw umber, Payne's grey and white dabbed on with a crunched-up piece of natural sponge. Paint the flowerpot in a mixture of cadmium red, yellow ochre and raw umber.

Tip

Large areas of texture like the concrete floor in the picture can be quickly achieved by painting with a sponge. However, the effect varies considerably depending on the type of sponge you use, so it is worth experimenting a little. The fine texture above is made with a tiny natural sponge — the sort used by watercolour painters to remove colour. The other texture is made with a bath sponge with large, irregular holes.

Tip

Drybrush, one of the most versatile of all painting techniques, is used in the picture to depict sunlight falling on the woven texture of the hat. With practice it is possible to achieve an evenly graded colour by gradually reducing or increasing pressure as you paint (*top*). You can also build up bolder woven patterns using overlaid, criss-cross strokes (*bottom*).

STEP 5

Paint leaf shadows on the wall in Payne's grey with a little white. Finally, mix undiluted yellow ochre and white for the straw texture on the hat. Squeeze the moisture from a 6mm (¼in) brush and dip the dry bristles in the thick paint. Draw the bristles lightly across the hat in the direction of the weave.

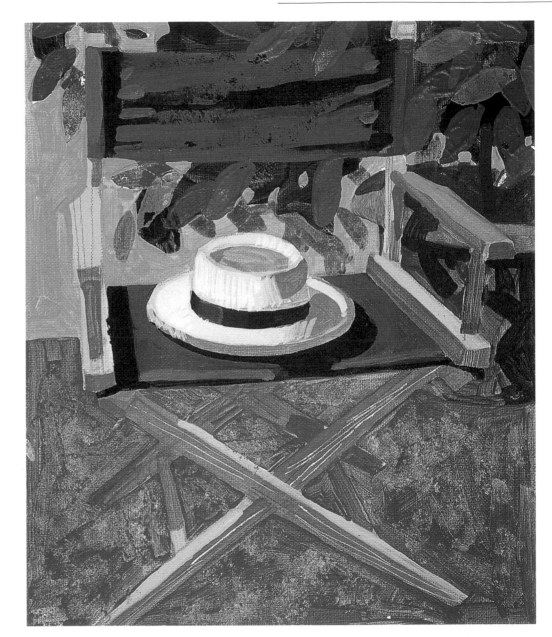

Landscape

Sweeping valleys, frothy streams, craggy mountains, shady woodland – these are just some of the scenes which spring to mind when we think of landscape painting. Equally important are the manmade landscapes – the towns and cities, the factories and industrial complexes. These may be less picturesque, but they have always held an equally strong fascination for artists.

Like the landscape itself, acrylic can be

Aims

- To create an illusion of space and distance by using linear perspective and atmospheric perspective
- To recreate natural textures and rhythms of landscape by using sponging, spattering and other paint techniques
- To mix a variety of greens from colours on the standard palette
- To find simple ways of painting water, including moving water and reflections
- To capture an impression of a landscape using broad blocks of colour and impressionistic brushstrokes

infinitely varied. Thick, buttery colour will form surface textures to match any in the natural or manmade landscape. Diluted acrylics can recreate the loose splashy effects of skies and clouds, of rain and water. And in addition, paint can be spattered, dribbled and dripped to create instantly the illusion of flowers, foliage, snow and watery spray.

On the following pages are three contrasting landscapes, each treated and painted in a different way.

MIXING GREENS

There are more greens in a rural landscape than you will have on your palette.

Bright greens are not a problem; mixtures of lemon or cadmium yellow with any of the blues on the basic palette will provide a range of good greens.

However, the greens of nature are varied and subtle. Compare the greens in a single tree. Some contain a lot of grey, others have a predominance of blue or orange. Try mixing cadmium yellow or yellow ochre with Payne's grey as well as with the

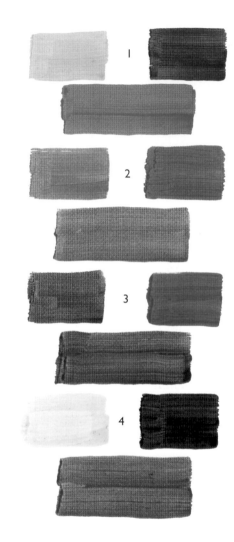

MIXING GREENS

1 cadmium yellow + phthalo blue
2 yellow ochre + cerulean blue
3 raw umber + cerulean blue
4 lemon yellow + Payne's grey

basic blues. The range will be increased enormously.

The greens illustrated here show a few possible mixtures, but it is a worthwhile exercise to try some for yourself.

CREATING AN ILLUSION

Landscape is full of rich textures. But just how do you paint the velvety surface of a moss-covered tree-stump or the lichen on a drystone wall? And how is it possible to create in acrylics a field of wild flowers or the dappled light on a tree in full foliage?

The answer is: it can all be done quite simply by using the paint effects you tried out in the previous lesson.

Painting a landscape is rather like painting scenery for a stage production. The audience sees a realistic scene, but from close quarters, it is unrecognisable, and all you can make out are enormous brush-marks or blobs of colour.

The scene is an illusion, and you can do exactly the same with a landscape painting. So be like the stage painter and use tricks and short-cuts in order to create on canvas the illusion of real landscape.

SPONGE AND SPATTER

The painting here shows two effective and time-saving techniques.

The first is to dip a sponge in a light green paint mixture and stipple over a dark green base to create dappled light on tree foliage.

The second is to spatter colours with a toothbrush to create an impression of scattered flowers or blossom.

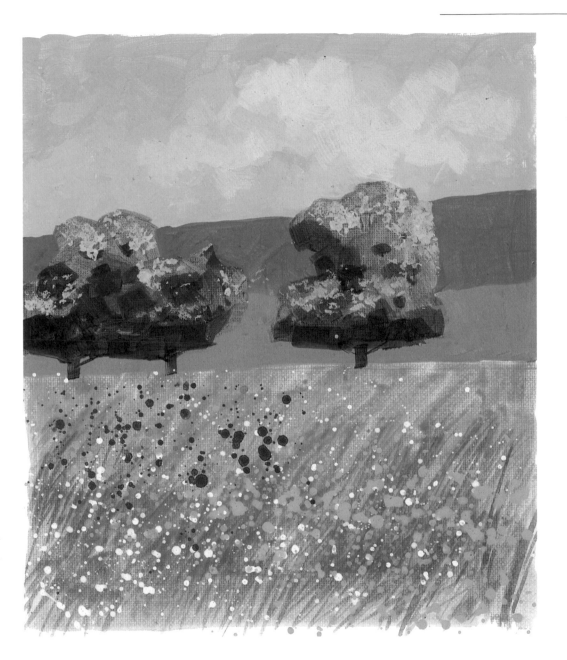

Quick ways with landscape include sponging pale green over dark to create light foliage, and spattering bright colours to create the impression of flowers in the meadow.

Tip

Use an old toothbrush for spattering. Dip the bristles in the paint and flick the colour onto the canvas.

WINTER LANDSCAPE

In a wintry landscape, there are no wild flowers and no lush greens as there are in summer. But winter is by no means all greyness and dullness.

On a sunny winter's day, snow can look dazzlingly bright. Shadows reflect the colour of the sky, and everything appears crisp and sharply defined. There are no dingy greys and no muddy colours.

To capture this in a picture, colours must be as fresh and bright as possible. The painting must not be overworked and the colours should not be overmixed.

SNOW WITHOUT WHITE

By using the whiteness of the paper or canvas instead of white paint for the snow, you will avoid unnecessary painting. Sharply defined shapes and shadows can be painted on top of the stark white to give a crisp, fresh image.

A snow scene without any white. You can start a winter landscape by using the primed white paper or canvas to represent the snow. This saves time, and keeps the painting fresh and crisp during the early stages.

ATMOSPHERE AND DISTANCE

Looking at objects in the distance, you will notice that the further away they are, the more hazy and indistinct they appear to be. Edges become blurred, and colours appear to fade.

Distant objects also appear to contain more blue than those in the foreground.

Thus a range of hills in the far distance is not only paler than hills which are nearer, but they are also bluer.

Look at a tree near to you, and you will see a range of different greens. Look at a similar tree some distance away and the greens have merged into an overall greenish-blue.

CREATING SPACE AND DISTANCE

This misty effect is often referred to as atmospheric perspective because it is the hazy atmosphere between the viewer and the distant horizon which causes the apparent changes in colour and tone.

You can make constructive use of the effects of aerial perspective in your painting by blurring background shapes, and using cool bluish tones for far-off objects. These will then appear to recede, creating a sense of space and distance in your painted landscape.

WARM AND COOL COLOURS

Just as cool, pale colours appear to recede into the background, so strong or warm colours will seem to advance.

For example, the foreground grass in the picture below is sap green. This is a comparatively warmer and stronger colour than the background blues, and it makes the grass appear to jump forward.

Brushmarks can also be used to help create an illusion of space. Here, large brushmarks in the foreground create an impression of grass seen from close quarters.

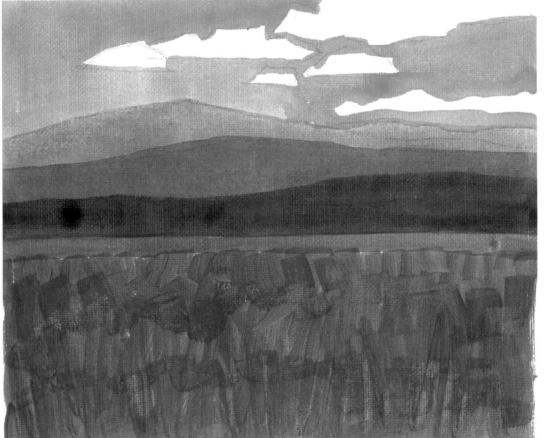

Tip

Even when painting interiors and landscapes you can help create a sense of space by painting objects in the foreground a little brighter than those a few feet behind.

ATMOSPHERIC PERSPECTIVE
The foreground is painted in strong sap green. The background hills become increasingly blue and faded as they recede into the distance. The distancing effect can be achieved by adding increasing amounts of blue and white to the background colour. Alternatively, add blue and dilute the colour with water to lighten.

COUNTRY CHURCH

When we think of landscape painting we immediately conjure up scenes of the rural countryside with hills, fields, trees and so on.

But we should remember that landscape is a broad genre which includes manmade as well as natural scenery. Therefore streets, houses, factories and city suburbs are all landscape subjects.

Inevitably, painting buildings and streets means coming to grips with perspective. We know that things appear to get smaller as they recede into the distance, and how the sides of road or railway converge on the horizon at a single point. Exactly the same principle applies to urban architecture.

LINEAR PERSPECTIVE

Unless you are standing squarely in front of a building, visible walls and rooftops of the building which are on the same plane and which run parallel to each other can be extended in the imagination or on paper until they meet at a vanishing point on the horizon. This makes linear perspective sound highly technical, but the principle is clearly illustrated here on the diagram of the church.

Good perspective in a painting goes unnoticed and is taken for granted. Unfortunately, if the perspective is wrong it

LINEAR PERSPECTIVE

Parallel lines on the same plane meet at an imaginary point on the horizon known as the vanishing point. To draw the church in correct perspective, make sure that the wall and roof lines which run in the same direction meet at the same vanishing point.

instantly attracts attention.

Check the accuracy of your converging lines with a simple test. Place your pencil on each of the drawn lines in turn. Slide the pencil along each line towards the horizon line. Parallel lines which are correctly drawn will converge and meet at the same place, the vanishing point.

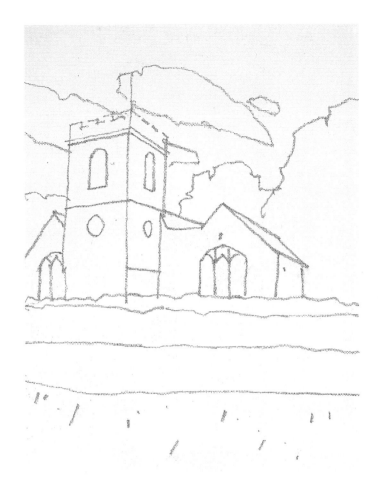

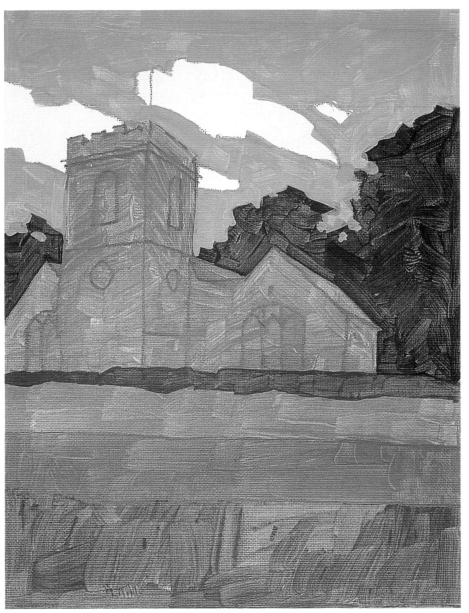

Using the 12mm (½in) brush, mix a brick colour from yellow ochre, cadmium red, burnt umber and a little white, and block in the church. Paint the sky in a mixture of cerulean blue and white, and the grass and foliage in mixtures of sap green, Payne's grey and white.

For this project you will need:
Palette colours
Brushes: 3mm (⅛in), 6mm (¼in)
and 12mm (½in) flats
Sheet of Cryla paper 31x23cm (12x9in)
Carbon pencil for drawing

STEP 2

Paint the bricks on the shaded side of the church, the windows and the roof in the first brick colour, with varying amounts of added burnt umber and Payne's grey. Darken shady areas of the foliage by adding more Payne's grey and sap green to the first mixture. Add white to this mixture and paint the pale areas of foliage. Darken areas of sky with the first mixture plus added cerulean blue.

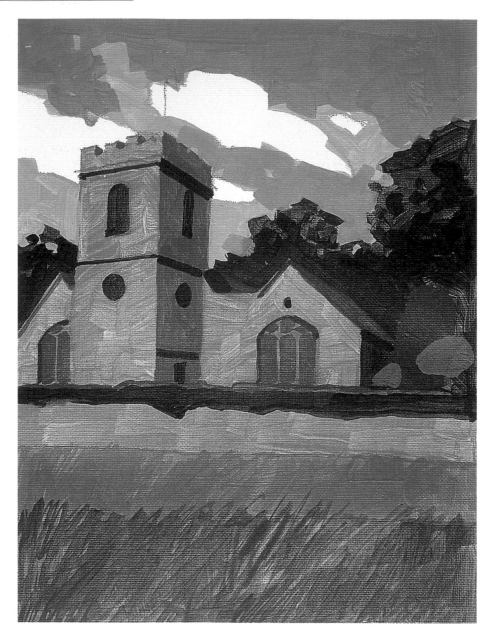

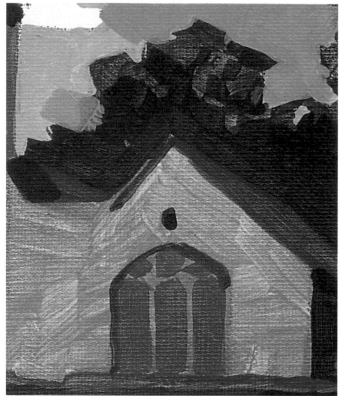

DETAIL

The initial painting shows the main areas of light and shade, loosely applied in thin colour. Keep the brushwork fresh and sketchy – there is no need to tighten or tidy the strokes.

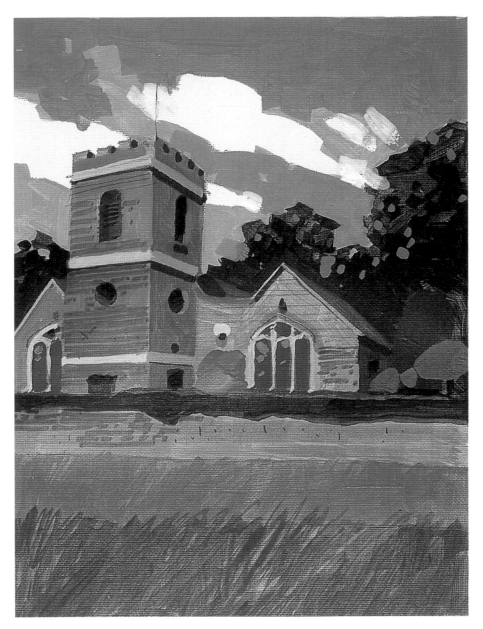

With the 3mm (⅛in) brush, add the small trees in the light green mixture. Strengthen the windows in Payne's grey and add reflections in cerulean and white. To suggest the brick texture, paint broken lines in a mixture of burnt umber, cadmium red and white. Finally, define a few rows of bricks with lightly drawn lines of carbon pencil.

DETAIL

Random blobs of blue to indicate reflected sky are all you need to bring the windows to life. The brickwork is suggested with a few lines in paint and pencil.

WATER

Water is transparent and depends on its surroundings for its colour. In any painting, the colours you will need to paint the water are simply those used elsewhere in the composition. There is no need to mix a special colour for the water.

The tricky aspect of painting water is that it rarely stays still long enough to get a proper look at it. Even with still water, the surface is not usually completely still, but is constantly interrupted by ripples and movement.

SURFACE PATTERNS

Any movement across the water surface causes ripples which create patterns of reflected colour. Continuous movement makes these patterns appear complicated and difficult to distinguish.

But by looking at a photograph of reflections on the surface of water, you will see that the patterns are in fact made up of very simple shapes which are quite easy to paint. A few of these patterns will create a convincing impression of water – there is no need to paint every single wave or ripple.

ONE-COLOUR WATER

Water which reflects only the sky can be painted using just one colour and white. This applies whether you are painting a pond, swimming pool or the sea. The principle is exactly the same and the same approach can be used.

In the two examples shown here, the sky colour which is reflected in the water happens to be greenish-blue. However, skies change depending on the weather and time of day, so you could just as easily be using bright blue, grey or sunset yellow.

Remember, when looking across an expanse of water, waves and ripples appear smaller the further away they are. In the top painting, each wave is painted with a single brushstroke. These become paler and smaller as they disappear into the distant shadow.

A simple formula for painting water using diluted paint: a single colour against the white of the paper creates the effect of ripples; in the foreground, the colour is stronger and brushstrokes larger.

When working in thick colour, create the effect of surface ripples by applying white paint in long irregular strokes over two tones of greenish blue.

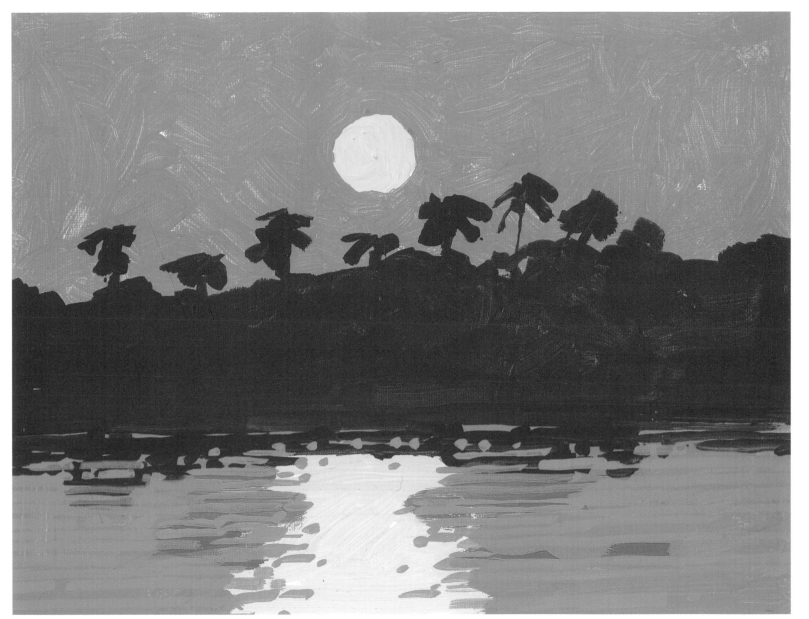

The exact colours of the setting sun and the silhouetted palm trees are repeated in the reflections. But because of the movement on the water surface, the image is broken up and depicted as short, horizontal brush-strokes of colour which represent the ripples.

REFLECTIONS

On a bright, still day reflections in water can be as clear as the surrounding landscape. If you were looking at a photograph instead of the actual scene, the picture could be turned upside down and it would be very difficult to differentiate between the real hills and trees and their reflections.

REFLECTED COLOUR

Because the same colours are used for both the landscape and the reflections, it makes sense to paint the two at the same time. This approach will also help integrate the water into the picture, rather than give it the appearance of something which has been added later.

For example, this landscape painting of a bridge over the river was started with the dark green of the trees. Using the same brush and the same colour, the reflection of the dark green trees in the bottom half of the picture was then painted.

The pale green of the trees was painted next, followed by the same pale green in the reflections. In this way the landscape was systematically built up – trees, followed by the reflections of trees; the hill followed by the reflection of the hill, and so on until the picture was complete.

REPEATED COLOUR

On a calm day, reflected colours are exactly those of the surrounding environment. In this painting, the water was painted concurrently with the hills, sky and trees – each time a colour was introduced into the scenery, the same colour was applied to the corresponding reflection in the water.

A few final ripples of hill colour were painted to break up the reflected sky and indicate the slight movement of the water surface.

Swimming pool water can be painted to a simple formula. A loose wash of bluish green is first applied to the entire water area. Irregular patches of a darker colour, rather like rounded jigsaw pieces which do not quite fit together, are painted over the wash. Finally, thin squiggly strands of reflected light are painted in opaque white.

THE OLIVE GROVE

Time is often limited for artists, especially when painting out of doors. Whatever the season or climate, weather can never be taken for granted. Wet weather creates obvious difficulties, but when working with acrylics the heat and sun can also be a problem because the paint dries quickly both on the palette and on the canvas.

Moreover the artist has no control over the light which changes constantly, causing colours and tones to look different from one moment to the next.

CREATING AN IMPRESSION

One way around the problem is to create a general impression of the subject rather than a detailed rendering. This way, the painting can be kept general and fluid, enabling you to alter tones and colours quickly and easily to match the changing light as the work progresses.

The 'impressionistic' approach is even quicker if you work from thin to thick – starting with broad strokes to make rapidly drying washes and building up thicker colours gradually.

As you can see from the painting, loose strokes of impressionistic colour work particularly well when painting the rural landscape. You can paint quickly, capturing

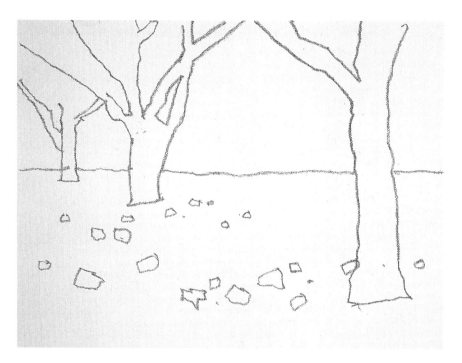

changing light before it has time to alter.

The olive grove was painted in early morning. It had to be done quickly before the sun got too strong – both for the artist, and for the acrylic paints which dry quickly in extreme heat. The thick to thin, impressionistic approach was ideal.

THE EDGES OF THE PICTURE

Working in a wide open space can be daunting because there are no obvious 'edges' to the scene as there are with an interior or a still-life subject. This is especially true of open landscape subjects like

For this painting you will need:
Palette colours
Brushes: a No. 4 round, 6mm (¼in) and 3mm (⅛in) flats
Sheet of Cryla paper 23x31cm (9x12in)
Carbon pencil for drawing

this olive grove, when vast expanses of similar scenery have no obvious elements or landmarks to frame the composition.

When confronted with such open landscapes, use the L-shaped brackets described on page 28.

Palette

CADMIUM YELLOW

YELLOW OCHRE

CADMIUM RED

ALIZARIN CRIMSON

BURNT UMBER

CERULEAN BLUE

PAYNE'S GREY

SAP GREEN

VIRIDIAN

TITANIUM WHITE

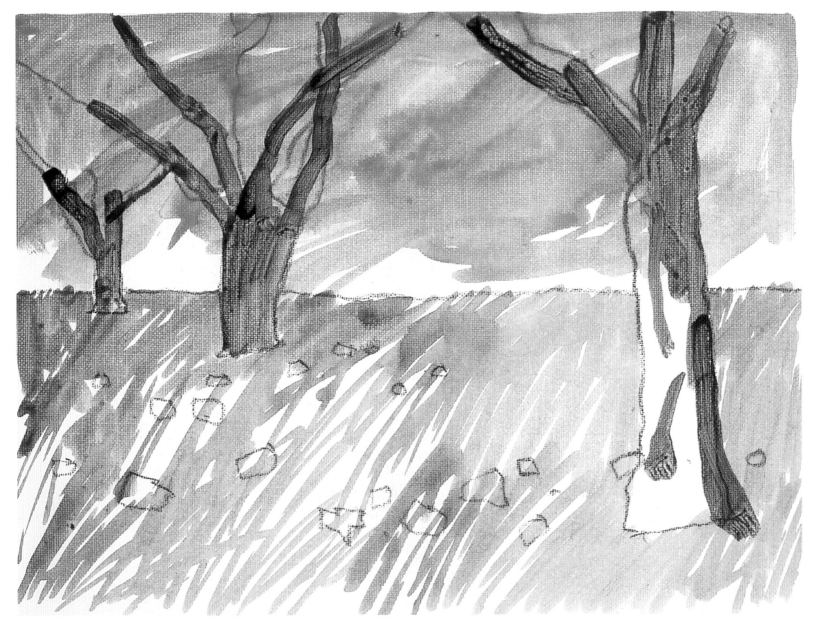

STEP 1

Using the 6mm (¼in) brush and a very thin mixture of viridian and Payne's grey, loosely paint the shapes of the tree foliage. Paint the shaded areas of the tree trunks in a thin mixture of Payne's grey and burnt umber. Change to the round brush and loosely brush in the foreground grass with thin sap green and cadmium yellow in loose diagonal strokes.

STEP 2

Mix viridian, yellow ochre with a little Payne's grey and white for the olive leaves and paint these and roughly dot in the leaves using the tip of the 3mm (⅛in) brush. Add a little more ochre to the leaf mixture and paint the distant greenery. Dot in the flowers with cadmium yellow and cadmium red. Paint the pale sides of the trunks in Payne's grey, burnt umber and white.

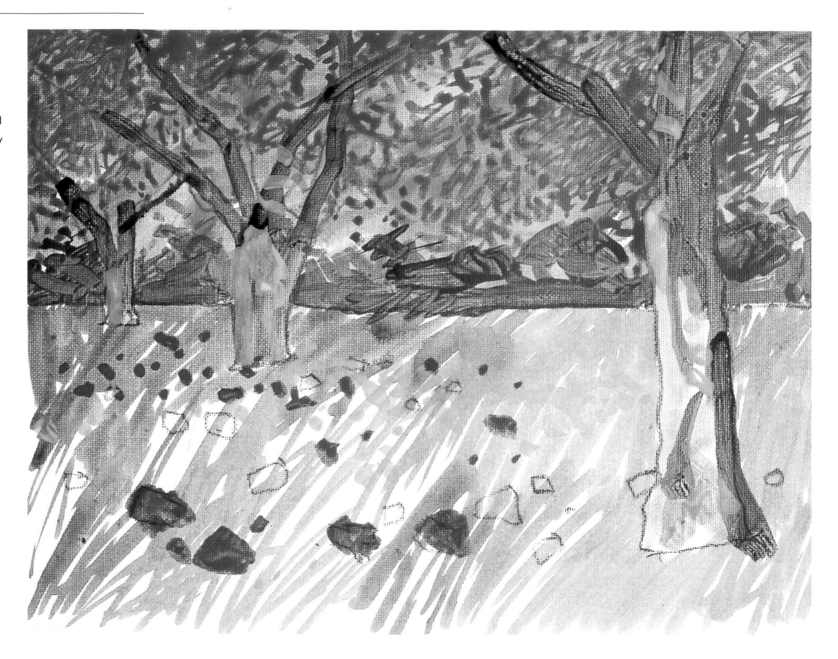

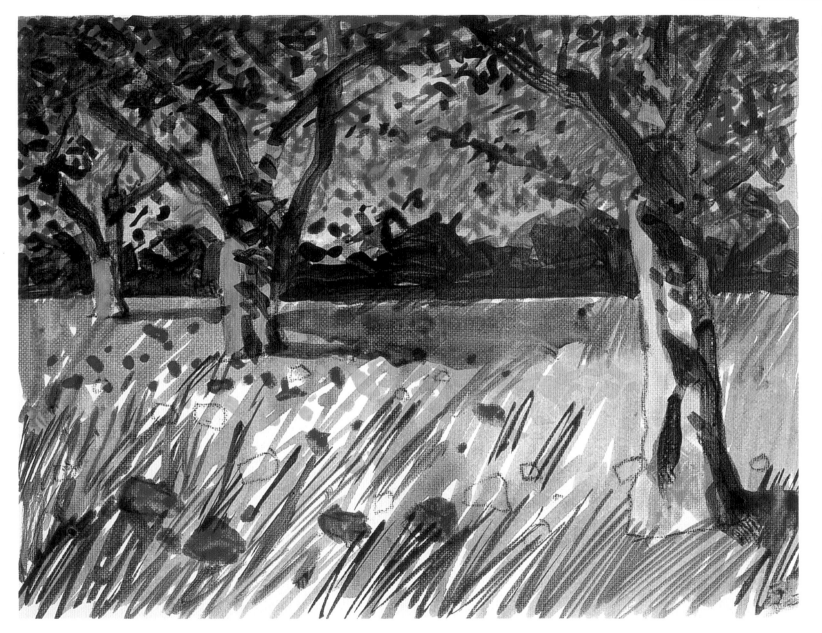

Darken the first olive leaf mixture with burnt umber and more Payne's grey and paint the dark leaves and the shadows. Using a thicker mixture of the first grass colour, paint darker blades of foreground grass with the round brush. Use the same colour for the thrown shadows.

STEP 4

Using the round brush, strengthen the foreground grass with thick mixtures of light and dark green. Apply the colour in a short scrubbing movement allowing patches of the underneath colours to show through. For the dark green, mix sap green with a little Payne's grey and cadmium yellow. For the paler greens, add white.

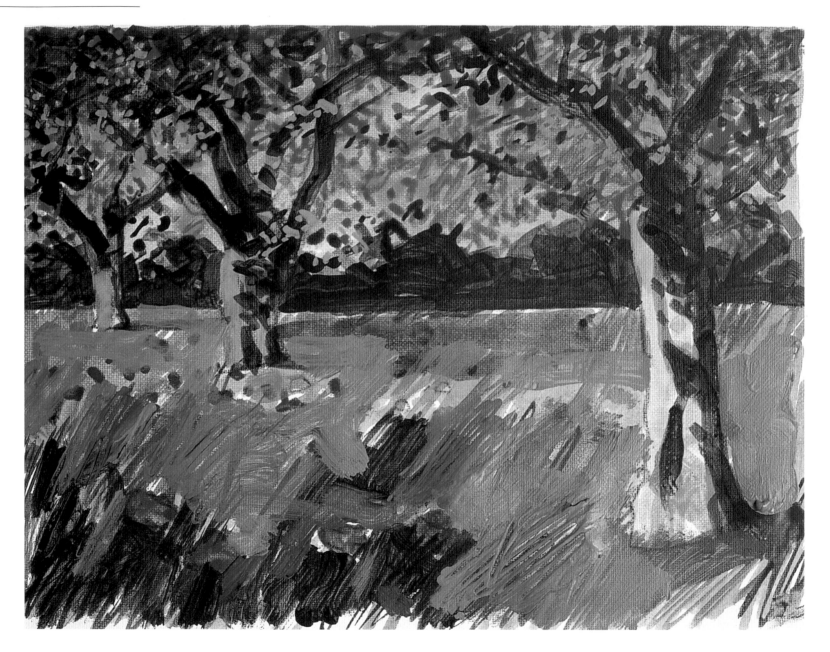

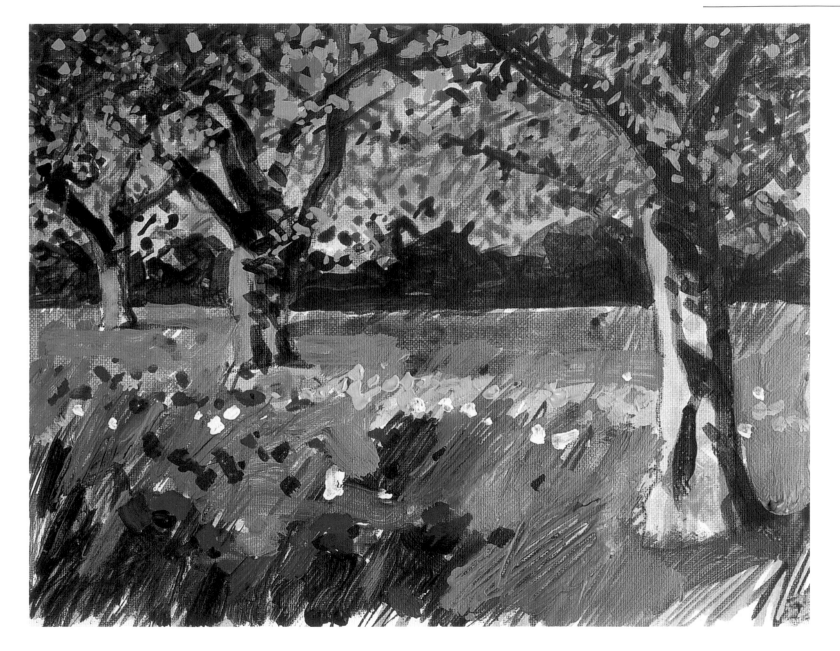

STEP 5

Change to the 6mm (¼in) flat brush and paint patches of blue sky between the branches in cerulean blue mixed with white. Finally, strengthen the flowers in thick cadmium red and cadmium yellow used straight from the tube. Use the end of the brush to make chisel-shaped marks which suggest the shape of flower petals.

People

Figure painting often looks more difficult than it is. This is because the human form is so often portrayed as an academic subject – one which is mysteriously more advanced than all other subjects that the artist encounters. And this means that many people are too intimidated to have a go.

However, it is important to bear in mind that the human subject is no different from any other. It is a series of shapes, colours and tones which can be arranged or simplified as you wish. In fact, in painting terms, your living model is much the same as the bowl of fruit in Lesson Two.

<div style="background:grey">Aims</div>

■ To capture movement and gesture with rapid sketches

■ To learn the proportions and structure of the human face and figure

■ To mix and achieve skin colours

■ To apply colour in thin layers of colour glazes

■ To extend an understanding of warm and cool colours

WARMING UP

Before moving on to the figure and portrait projects on the following pages, begin by loosening up with some quick sketches. The local park, station or bus stop is often a good place to start. Make some very quick sketches of the people there as they move around – walking, talking, sitting and so on.

Concentrate on movement, on gestures and postures rather than accuracy. In any case, your subjects will be moving so quickly that there will be no time to worry about anatomy and correct proportions.

Work directly in paint without making a preliminary pencil outline which would only slow down the process. Try to see the subject in terms of large, simple shapes. Follow the contours of the figure with broad, fluid brushstrokes; then block these in rapidly with solid areas of paint.

In these sketches, colours need not be accurate. Mix a few general purpose colours on the palette before you start and use these to approximate those in front of you. If the colours really slow you down then work with only colour and paint the figures as loose silhouettes.

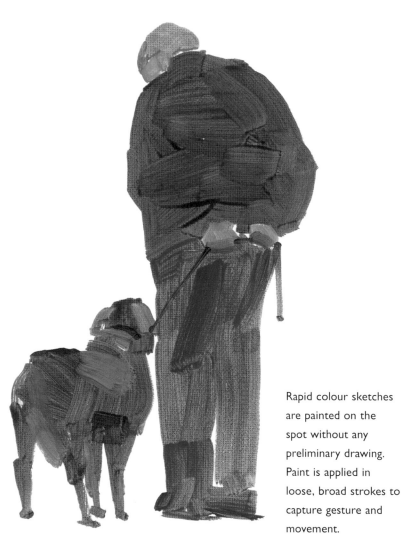

Rapid colour sketches are painted on the spot without any preliminary drawing. Paint is applied in loose, broad strokes to capture gesture and movement.

Use a large brush
for rapid sketching.
This helps to
establish the subject
quickly, and also
discourages the
temptation to depict
too much detail.

THE PORTRAIT

Few subjects are more challenging than the human head. It fascinates and compels and – more than any other subject – it is what many aspiring artists would really like to be able to paint. Yet even experienced artists find portrait painting one of the most difficult of all genres.

This is because the head is misleading. Because the features are so prominent, and because the face immediately draws our attention, it is easy to forget that the eyes, nose and mouth are only a small part of the whole head.

Odd as it may sound, the best way to get a likeness is to ignore facial expression. Forget the person you are painting and treat your human subject as you would treat any inanimate object – as a combination of forms, shapes, colours and tones.

THE HEAD

The easiest way to tackle the head is to think of it as an egg. To fix the position of the eyes, divide the egg in half horizontally. On most people, the eyes fall on or close to this half-way line. The eyebrows are then easily established in relation to the eyes.

Now, divide the distance between the eyebrows and the tip of the chin in half. This gives the approximate position of the base of the nose. Finally, draw a line to divide the space between the chin and the nose line to find the approximate position of the lower lip.

Obviously, these are guidelines only and will vary from person to person. However, until you have had some practice at portraiture, they can provide a useful and surprisingly accurate starting point.

THE RIGHT ANGLE

The choice of angle from which a head is painted is a personal one. Your subject can be painted in profile, from the front, or with the head half turned. The latter is often referred to as a three-quarter pose.

For the beginner, it is very easy to make a portrait in profile rather static and stiff. Your painting can end up looking rather like the head on the side of a coin. To start with it is probably wise, therefore, to choose a three-quarter view or a full frontal pose.

As a general rule, a full frontal pose should be lit from one side to lend form and interest to the face. Lit evenly, or from the front alone, a face can tend to look rather flat.

The human head is shaped rather like an egg. The eyes lie on an imaginary line which divides the egg in two horizontally. The base of the nose lies on another imaginary line dividing the space between the eyebrows and the chin. A third line between the chin and the base of the nose gives the position of the lower lip.

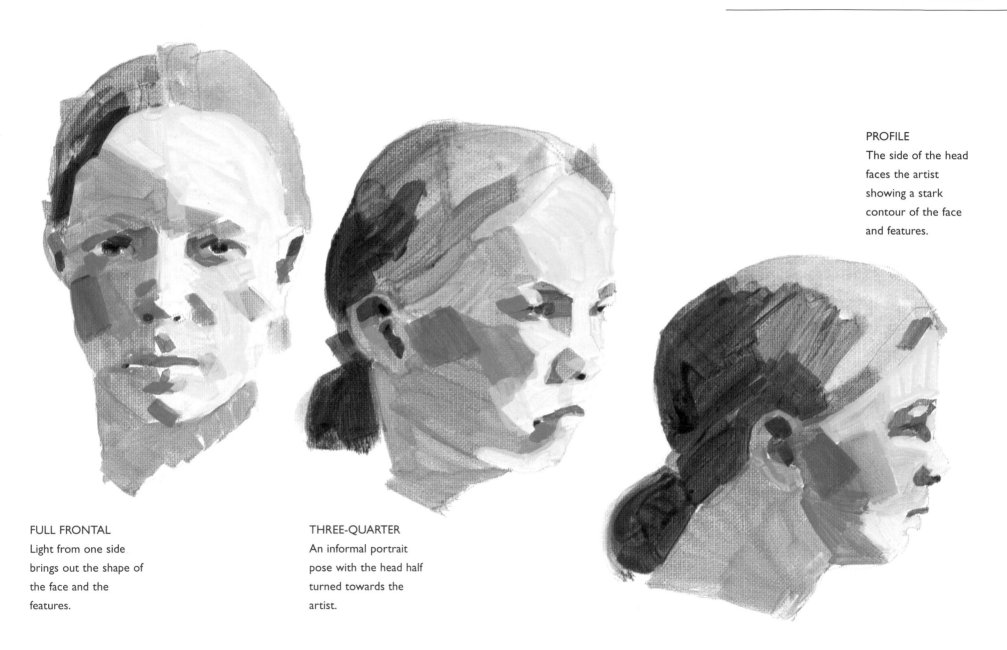

PROFILE
The side of the head faces the artist showing a stark contour of the face and features.

FULL FRONTAL
Light from one side brings out the shape of the face and the features.

THREE-QUARTER
An informal portrait pose with the head half turned towards the artist.

PORTRAIT OF A YOUNG GIRL

An accurate initial drawing is essential to portrait painters because it must establish the structure of the entire head. If the drawing is wrong then the subsequent painting will probably be wrong as well. Your drawing need not be detailed, but it must be accurate – especially the outline.

More important, the rounded form of the head is divided into areas of light and shade, or planes. These planes essentially show the changes of direction on the surface of the head. They vary from person to person and are generally more pronounced in elderly or very thin people.

PLANES

The main planes in this portrait are the flattened areas down each side of the face, and the areas around the mouth. Each of these main planes is divided into smaller planes of light and shade which can be established when you start painting.

For the time being, it is important to observe where the main planes are and to indicate these on the drawing. A strong source of light on one side of the subject will emphasise the light and dark planes and make them easier to see.

For this painting you will need:
Palette colours
Brushes: 6mm (¼in) and 3mm (⅛in) flats; No. 4 round
Sheet of Cryla paper 23x28cm (9x11in)
Carbon pencil for drawing

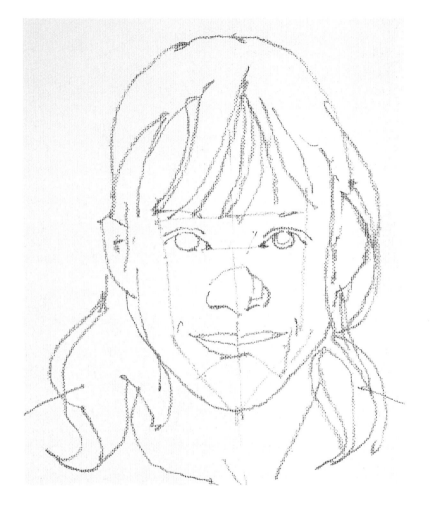

Palette

TITANIUM WHITE

LEMON YELLOW

CADMIUM YELLOW

YELLOW OCHRE

RAW UMBER

CADMIUM RED

ALIZARIN CRIMSON

CERULEAN BLUE

PHTHALO BLUE

PAYNE'S GREY

TONAL UNDERPAINTING

An underpainting in a single colour will help you work out where the light and shaded areas of the face lie before introducing the local colours.

Although blue may seem a strange colour for a portrait underpainting, there is good reason for this unlikely choice.

For the portrait of this little girl, the dusty blue complements the subsequent skin colours which are predominantly orange. In the final stages, the blue can be allowed to shine through the orangey skin colours in shaded areas to provide the cooler shadow tones.

As can be seen from the tonal scale, the range of blues can go from very light to very dark. However, for the purpose of this portrait, these can be simplified to just three – light, medium and dark.

By looking at the subject through half-closed eyes much of the local colour will be cut out and you will find it easier to pick out the lights and darks.

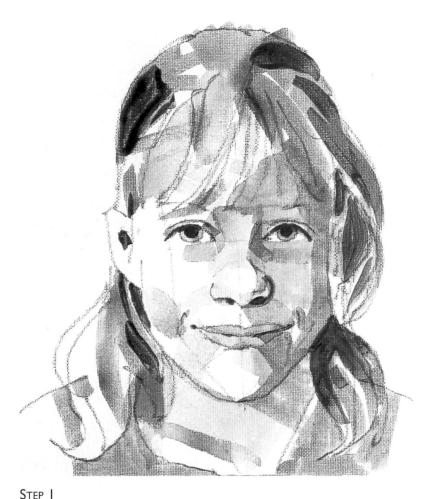

STEP 1

Mix three thin tones of underpainting colour from Payne's grey, phthalo blue and white. These should correspond roughly to the lightest, darkest and middle tone on the scale (*right*). Using the 6mm (¼in) brush, work from light to dark, loosely painting in the approximate tones of the face. Leave patches of white paper for the highlights.

TONAL SCALE

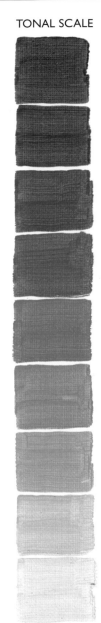

Any blue or cool bluey-grey can be used for the tonal underpainting in portrait painting, so experiment to see which you like best. The palette tones (left) are predominantly phthalo blue with touches of white and Paynes grey. In the portrait, the tones are mainly Paynes grey, touches of white and blue.

113

WARMS AND COOLS

The shaded parts of the face are cooler in colour than those areas which catch the light. The warmest tones are those mixed from cadmium red and cadmium yellow or yellow ochre. The coolest are those which contain a lot of blue or Payne's grey.

Use the blue underpainting as a guide to the skin colours. The pale blue denotes pale flesh tones; the darker blue marks the areas of cooler shadow.

A general guide to mixing cool skin tones is to start with a local colour – usually mixed from red, yellow and white – and to add the cooler blue or grey gradually until you get the right shadow tone.

Alternatively, you can achieve a cool shadow tone by using a thin wash of skin colour which allows the bluish underpainting to show through.

However, unless you are deliberately using thin colour for this reason, the paint at this stage should be getting gradually thicker – opaque enough to cover up the blue of the underpainting.

Apply colour with confident strokes and do not be tempted to tidy up the loose brushstrokes – the portrait will look much more lively if you leave visible patches of separate colour with ragged edges instead of trying to blend them together.

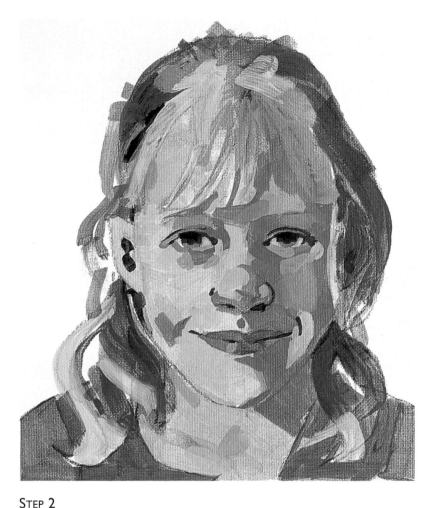

STEP 2

Paint skin colours using the 6mm (¼in) and 3mm (⅛in) brushes. Lightest tones are from white, cadmium red and cadmium yellow; darkest tones are alizarin crimson, cerulean blue and white. Use the chart on this page as a guide to medium tones, adding white for paler colours. Hair is raw umber, yellow ochre and white. Clothing is cadmium red, phthalo blue and white.

SKIN COLOURS

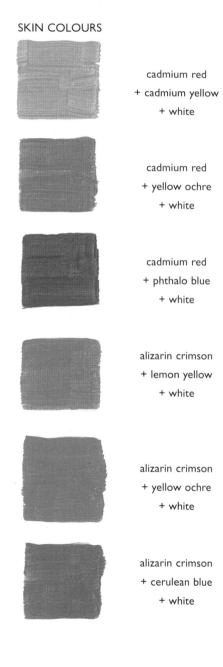

cadmium red
+ cadmium yellow
+ white

cadmium red
+ yellow ochre
+ white

cadmium red
+ phthalo blue
+ white

alizarin crimson
+ lemon yellow
+ white

alizarin crimson
+ yellow ochre
+ white

alizarin crimson
+ cerulean blue
+ white

FINISHING TOUCHES

There is a definite art in knowing when to stop work on a painting. In the final stages of this portrait, the colours and tones are developed and defined, but it is important not to overwork the paint or become too obsessed with detail.

The purpose of this final stage is to tighten up the image without losing the freshness and spontaneity of loose brushstrokes and bold patches of colour.

EYES

It is a common mistake for the inexperienced painter to pay too much attention to the eyes, often making them too defined and pale and so producing an unnatural, staring look. Paint both the eyes and eye sockets in exactly the same manner as you have handled the rest of the portrait – in broad, bold strokes.

Dark tones around the eyes help the eyes to recede into the sockets.

MOUTH

Planes of light and shade surrounding the mouth are as important as the mouth itself – without these the lips would appear merely as a flat shape on the surface of the face. Many muscles are responsible for facial expression and the movement of the mouth. In this portrait these are simplified into broad planes of very pale skin colour on the illuminated side of the face, and dark planes on the shaded side.

NOSE

The nose, like the head, has a definite structure. Apart from the dark tones of the nostrils and base, tones and colours on the nose reflect those on the face as a whole. Broad strokes of cool, bluish pink describe the shadows; the highlights are painted in chunky patches of lemon and white.

HAIR

Although everyone knows that hair is not solid, it is easier and more effective to treat it as such for the purpose of painting. Start by considering the overall shape of the hair, then think about the direction in which it is growing.

Broad strands of hair are painted in broad brushstrokes. The deepest shadows are painted in undiluted raw umber and appear almost black. Highlights on the hair are exactly the same as highlights on the skin in lemon yellow and white.

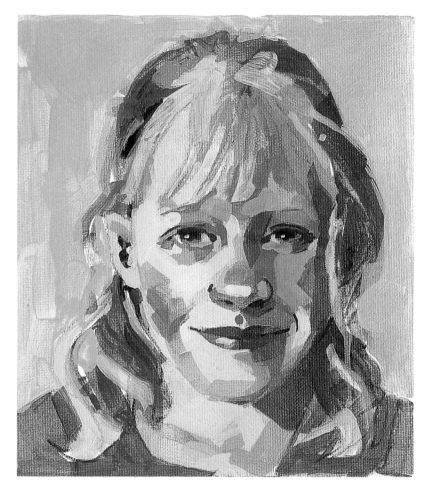

STEP 3

With the 6mm (¼in) brush, adjust light and dark skin tones. Colours are similar to the previous stage, but with more cerulean blue in the shadow colours. Palest skin tones are lightened with white. Highlights are a mixture of white and lemon yellow. Use the No.4 round brush to define lip colours in mixtures of alizarin crimson with touches of white and Payne's grey. With the 6mm (¼in) brush, paint the background white and cerulean blue with a touch of Payne's grey.

THE FIGURE

Outside the studio, figures are constantly moving and changing position. Quick-drying acrylics are the perfect medium for painting such subjects, but your approach must be adapted to keep pace with the subject.

One brushstroke must record a lot of information. As with the figures on this page, a single broad stroke is sometimes all that it takes to paint the shadow on an arm or leg.

As with portrait painting, the rapid drying quality of acrylics makes them a perfect medium for figure painting. Colours can be applied in thin layers, with warm tones being laid over cool ones to capture the elusive, translucent quality of human flesh.

FIGURE PROPORTIONS

An awareness of proportion and anatomy is essential to the figure artist. But this does not mean your painting must make a detailed study of the subject. It can be loose and fluid, capturing movement and gesture rather than a photographic likeness. As long as the basic proportions are reasonably correct, figure painting need be no more difficult or detailed than any other genre.

Before embarking on the figure painting project, it is worth noting a few helpful tips, but these should not dominate your approach – no two bodies are exactly the same. In any case, painting is for fun, not an exercise in measuring. However, the following tips do provide a useful checklist for figure artists, particularly when making the preliminary drawing.

GETTING IT RIGHT

On a standing adult, the length of the head is about one eighth of the whole body. In other words, the head fits into the body seven times.

The distance from the top of the head to the crotch is about half the total height of the figure. If your subject happens to be a nude, the top of the head to the navel is about three-eighths of the whole.

Also, watch out for the arms, which are always much longer than one would expect. On most adults, when the arms are hanging, the tips of the fingers come at least half-way down the thigh, sometimes more.

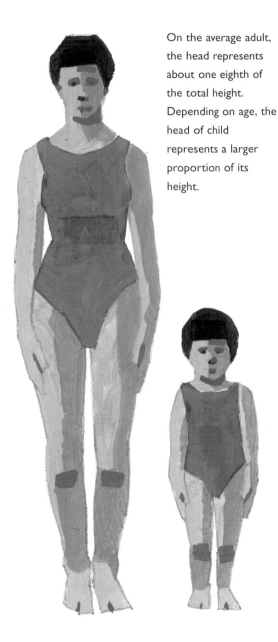

On the average adult, the head represents about one eighth of the total height. Depending on age, the head of child represents a larger proportion of its height.

STANDING FIGURE

Confine yourself to using large brushes for this figure painting. Painting eyelashes and fingernails with a big brush is well nigh impossible, so this self-imposed restriction will encourage you to concentrate on the main forms of the subject. It is the best possible introduction to figure painting.

The figure study is painted using the classic 'thin to thick' approach, starting with thin washes of colour. Paint is then built up gradually using increasingly thick colour.

Paint the figure first. This gives you the opportunity to redefine and sharpen the outline of the young man when you come to paint the background. This is done by painting up to and over the edges of the painted figure with the opaque background colour.

The chisel-shaped bristles of the flat brush enable you to lay strokes of paint both parallel and adjacent to the outline of the form.

CLOTHING

Do not be distracted by the jeans and shirt. They do not obscure the underlying form. Instead, make use of the folds and creases in the fabric which follow the contours of the body, making the form more visible and therefore easier to paint.

Even under loose drapes or a voluminous costume the figure underneath is visibly solid.

SIMPLIFY

The big brushes make it necessary to simplify everything, even the colours. Limit the main colours to just three tones – dark, medium and light. Use the medium tone for the local colour, and the pale and dark tones for areas of light and shade.

For example, the denim jeans are medium blue. The darker blue is used for the shadows, and the pale blue to indicate areas of sunlight on the denim fabric.

FLOWING STROKES

With practice, elongated shapes of shadow and sunlight like those down the sides of the legs and along the length of the arm can be painted in a single unbroken brush-stroke.

Although this is not an essential skill, flowing undulating strokes echo the fluid forms of the human body and can be used to create attractive rhythms and movement in figure painting.

Palette

ALIZARIN CRIMSON

BURNT UMBER

YELLOW OCHRE

CADMIUM YELLOW

CERULEAN BLUE

PAYNE'S GREY

SAP GREEN

TITANIUM WHITE

For this project you will need:
Palette colours
Brushes: 12mm (½in) and 6mm (¼in) flats, 12mm (½in) filbert
Sheet of Cryla paper 31x20cm (12x8in)
Carbon pencil for drawing

STEP 1

With the 12mm (½in) brush, paint the skin tones in a diluted mixture of white, alizarin crimson and yellow ochre. Using equally thin colour mixtures, paint the hair in raw umber and Payne's grey, and the shadows on the jeans in cerulean blue toned down with a little of the skin colour.

STEP 2

Paint the shirt in diluted alizarin crimson, yellow ochre and white; the boots in yellow ochre; the belt in burnt umber and Payne's grey; and the jeans in the first blue mixture lightened with a little white.

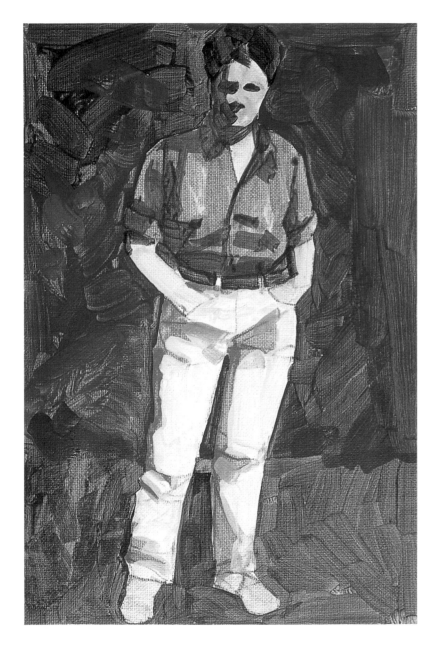

STEP 3

Loosely paint the background in sap green, Payne's grey and white. Correct and adjust the figure outline by overpainting where necessary. With the filbert brush, darken shadows on face and arms using the first skin mixture with added raw umber and alizarin crimson.

STEP 4

Add background details in light and dark greens. Using darker mixtures of the original colours, strengthen shadows on clothing with the 6mm (¼in) brush. Paint pale shirt areas in alizarin crimson, white, and a little Payne's grey. Highlight skin tones in a pale mixture of alizarin crimson, cadmium yellow and white.

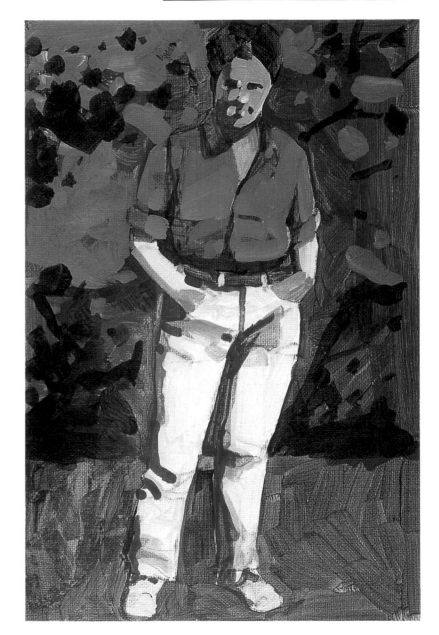

Collage

Both acrylic paints and acrylic mediums are adhesive – ideal for collages and mixed media work. Fabrics, crumpled papers and other textured and patterned materials can be stuck directly onto a painting. You can paint over these to integrate the textures into the painting, or simply leave them alone for their collage effects.

BE INVENTIVE

All sorts of materials can be embedded or pressed into the wet paint or medium which will then dry to a permanent finish. Also, acrylics are inert which means that, unlike some glues, they do not melt or go 'off'.

The potential for acrylic collage is truly enormous. Cloth and paper are simple to stick down and can be used as flat shapes, or crumpled and creased to give a rough, craggy texture. But with acrylics you are not confined to two-dimensional materials. A creative collage can include almost anything – including sand, gravel, straw, dried food, plastic objects and string.

If the wet paste is not strong enough to stick heavier items, it might be necessary to keep the collage horizontal until the acrylic is dry.

Once you are hooked on collage, the possibilities are endless and you will start to accumulate a ready supply of materials. So think before discarding any interesting or unusual materials and scraps.

Aims
■ To explore the adhesive properties of acrylic
■ To introduce new materials into your work, including fabric and paper

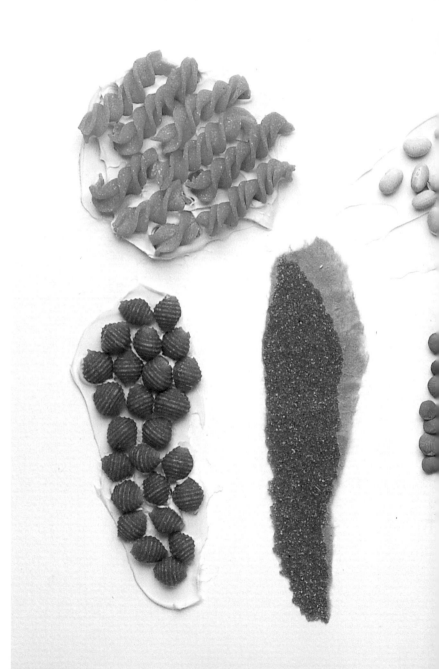

A few of the many everyday materials which can be used to create collage. These include pasta, seeds, nuts, tablets, muslin, string, fabric and sandpaper. Materials can either be embedded in modelling paste, mixed with paint or medium, or glued down using acrylic medium as glue. Collage materials can be painted or left in their natural colours.

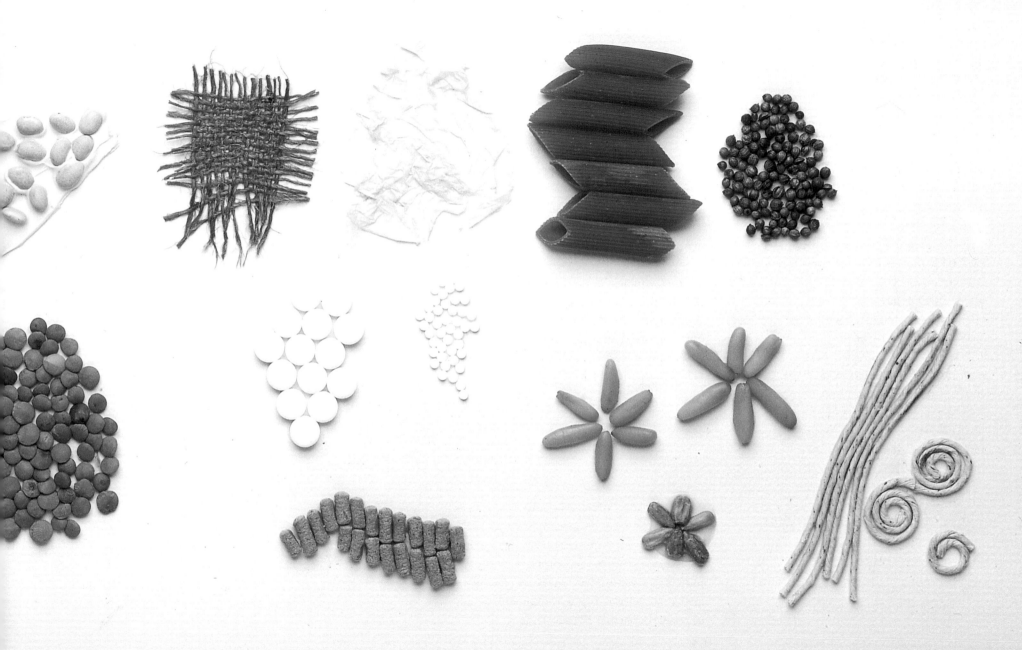

COLLAGE STILL LIFE

Often there is no real dividing line between a collage and a mixed media painting. Elements of collage can be introduced into an acrylic painting; painting techniques can be used in a collage. In addition, a collage may include any of the texture-making techniques and materials which have been described earlier.

Collage is essentially a personal and experimental art form and it would be useless to give labels or to categorise particular works. To illustrate the point, this project starts as a painting, continues as a collage and ends up as a piece of graphic design!

ARRANGING THE SHAPES
There is no preliminary drawing for this collage. Instead, the first stage is to paint the whole paper with broad brown streaks. This is the table top – the base on which all the other elements will be arranged.

The main shapes are the plate and jug. Before sticking these down, move them around on the painted paper until you find a composition you like. Bear in mind that the background areas should also be considered as shapes in their own right.

The space within the handle is a positive shape. The other, larger background area is transformed into a more effective shape by taking the plate over the edge of the picture area.

PAINTED PAPER
Oranges and lemons are torn from sheets of painted paper. The torn edges resemble the irregular skins of the real fruit and contrast effectively with the hard cut edges of the apples, jug and plate.

A great advantage of painting your own papers is that you can get the exact colours you want instead of relying on the manufactured coloured papers. In this case, the painted textures are also an important part of the design.

Paint all the papers before starting to stick down the collage, painting a few extra in case of mistakes. This gives time for the paint to dry and also avoids smudging colours with sticky hands.

STICKING DOWN
Use matt medium for sticking the pieces. This goes transparent as it dries. Some of the painted paper shapes may have curled a little. If this has happened, place something heavy on top of the stuck-down shape and leave until dry.

For this project you will need:
Acrylic matt medium
Brush
Drawing pencil
Scalpel
Newspaper
Muslin or scrim
Sheets of painted cartridge
Sheet of Cryla paper 28x38cm (11x15in)

STEP 1
Using a brush, paint a streaky wash of raw umber, yellow ochre and white over the Cryla paper and allow to dry. Squeeze excess moisture from the same brush and dip the tips of the bristles in a mixture of burnt umber and Payne's grey. Drag this quickly across the paper to indicate horizontal wood grain.

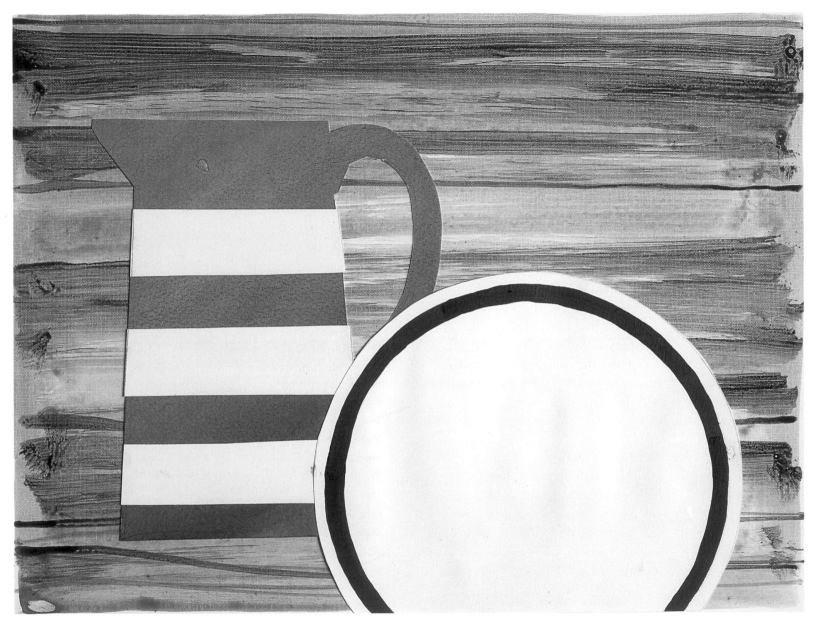

Draw and cut the jug shape from the light blue sheet. Cut and stick on the white stripes. Draw and cut out the circular plate from white cartridge paper and paint the stripe in phthalo blue, using compasses and a pencil to draw a guide line. Arrange the shapes on the painted background and stick down with matt medium.

STEP 3

Draw the fruit shapes on the back of the painted papers. Using the pencil outlines as guides, carefully tear out the oranges and lemons. Cut out the apple shape with a sharp scalpel. Stick down. Tear and cut the shadow shapes of the jug from the dark blue painted paper, and stick in position.

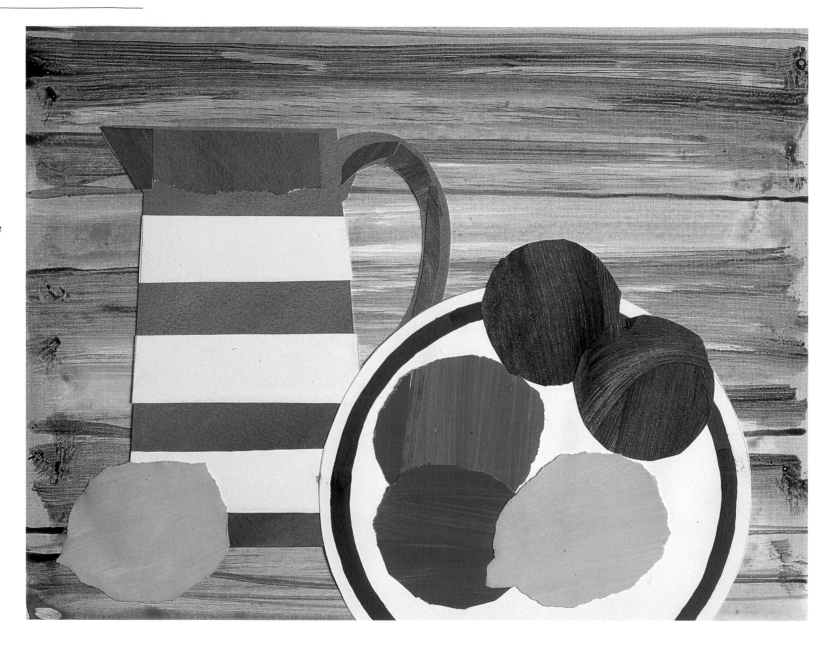

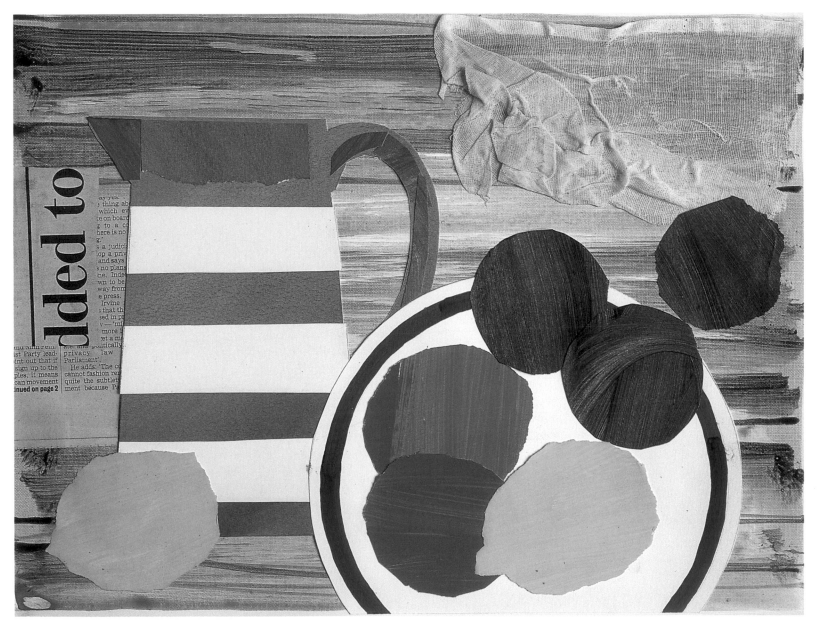

Cut a piece of cotton scrim or muslin for the crumpled napkin. Place in position, crumple and glue down by forcing matt medium through the fabric with a stiff brush. Cut newspaper shapes and stick down, pushing the edges of the newspaper up against the side of the jug.

GLOSSARY

acrylic a quick-drying paint in which the *pigment* particles are suspended in a synthetic resin. This comparatively new medium is water-soluble and permanent.

acrylic gesso not to be confused with real gesso, this is an acrylic primer which gives a bright white surface for painting on.

adhesive acrylic mediums have adhesive properties similar to those of woodworking glue. They can be used for sticking paper, wood, plastic and many other materials to the painting surface.

atmospheric perspective when distant objects and scenery appear paler and bluer than foreground objects due to the haziness of the intervening atmosphere.

binder a liquid or viscous medium which is mixed with *pigment* to produce paint.

blending merging two or more colours together in such a way that the join is invisible. See *fan*.

bright a square-headed, flat brush with short, stiff bristles.

carbon pencil a pencil with a soft, crumbly core which produces a line similar to that of charcoal.

collage picture built up by sticking shapes of paper, card, fabric and other materials on a support.

composition the arrangement of shapes, colours, tones and textures to make a picture.

covering power refers to the *opacity* of a colour and its ability to obliterate other colours by painting over.

fan brush with a splayed, fan-like bristle head used largely for *blending* colours.

ferrule the tubular metal part of a brush which holds the bristles in place.

filbert a brush with a slightly tapering bristle head and a flattened *ferrule*.

flat a brush with square bristle head and a flattened *ferrule*.

flow improver an acrylic medium which can be added to the paint to make it easier to spread. Especially useful for large expanses of colour.

gel medium acrylic medium used for thickening and increasing the viscosity of the paint.

glazing applying a layer of transparent or semi-transparent colour over another colour.

gloss medium an acrylic product which has *adhesive* properties and which can be mixed with the paint to create a glossy paint surface when dry.

graphite pencil a drawing pencil with a core of graphite and clay and which has virtually replaced the original lead pencil.

impasto paint which has been applied thickly to the support, usually to create a textural effect. Impastoed paint can be applied with a brush or knife.

linear perspective a system used by artists in order to create accurate distance and space in a picture. It is based on the law that receding parallel lines on the same plane converge at the same imaginary point on the horizon, the *vanishing point*.

local colour the actual colour of an object when not affected or modified by light, shade or atmosphere.

masking the technique of protecting a selected area of the painting when applying colour.

masking tape adhesive tape used for *masking*. The tape is easily removed from the support when the paint is dry.

matt medium an acrylic product with adhesive properties which can be mixed with paint to create a dull, matt finish when dry.

medium the material used by the artist for a particular work – acrylic, watercolour, etc. The word is also used to describe the various additives and products which can be mixed with paint to create particular effects.

mini sketch a small, quick drawing done in order to help the artist plan the composition, colour, etc, of a larger work.

moist palette a special *palette* for use with acrylic paint which is designed to keep the paint moist and usable for several hours.

monochrome a painting or drawing done in one colour or black and white.

negative space the shapes of the empty background spaces around the subject.

opacity the ability of a *pigment* to hide or cover another pigment. See *covering power.*

painting knife a knife with a flexible blade and a bent, or cranked, handle used for applying paint to the support.

palette the flat surface on which the paint is laid out and mixed. The term is also used to describe the colour selection used by the artist.

palette knife a knife with a long flexible blade used for mixing paint and removing paint from the *palette.*

pigment the colouring substance of paint and other artists' materials.

planes the surface areas of objects which are seen in terms of light and shade.

primary colours painting primaries are red, yellow and blue. Primaries cannot be mixed from any other colours.

render to draw or reproduce an image.

retarder acrylic medium which can be mixed with the paint to slow down the drying time.

round brush with a rounded bristle-head contained in a round *ferrule.*

secondary colours colours mixed from two of the *primary colours.* Orange, violet and green are the artists' secondary colours.

spattering texture-making technique done by flicking flecks of colour from a loaded brush.

spectrum the colours produced when light is passed through a glass prism.

staining capacity the colouring strength of a pigment.

stencil cut-out shape or pattern in a sheet of card or similar material. The motif is then painted by stippling or painting through the cut-out hole.

still life a group of objects, usually inanimate, arranged as a painting subject.

stipple making painted texture by dabbing colour on to the support. Special stippling brushes are stiff and cut to create a flat end when used in an upright position.

stretcher the wooden frame over which canvas is stretched to form a painting surface. Self-assembly stretcher pieces are available in a variety of lengths.

support a surface for painting or drawing on. For acrylics, the support is usually treated or primed ready to receive paint.

texture the surface or tactile qualities of the painted surface.

texture paste acrylic medium used for stiffening the paint in order to create pronounced textures. Paste can also be applied on its own and painted over when dry.

tone the light and dark values of a colour. For example, Payne's grey is dark in tone; lemon yellow is pale.

transparent the *glazing* potential of a colour depends on its transparency. Some pigments are more transparent than others.

underpainting a term usually used to describe the initial blocking in of the main colours of a painting. Sometimes refers to the painted outline drawing done prior to painting.

vanishing point the imaginary point at which converging parallel lines meet on the horizon line when constructing *linear perspective.*

wash area of diluted colour applied thinly to the *support.* Acrylic washes look like watercolour painting.

INDEX